PROTEST
ART

PROTEST
ART

—

JESSICA
LACK

—

CONTENTS

INTRODUCTION

This is a book about art and protest and how artists have
responded to power by putting their imaginations to
the service of political change. It travels through the
grand narratives of Modernism, the anti-authoritarianism
of Postmodernism and the contradictory chaos of the
digital age.

It does not offer an easy-to-summarize definition of what
protest art is. How could it, in a world of such ambiguous
dysfunction? What it does is present a series of rallying
cries by artists determined to play their part in troubled
times by defending truth, instinct and humanity against
the cold formations of political power.

Protest art is intrinsically linked to the world in which
it was created. Work that easily chimed with the
vernacular of the day can look oddly impotent when
detached from its social context and isolated from
the environment in which it was made. The political
concerns of the artists featured here are multiple and

diverse, and time is given to locating the works in their respective milieus.

Ultimately this book shows how protest art can initiate dialogue, communicate defiant messages and explore political alternatives to the status quo. As the Indian painter Francis Newton Souza wrote in his 1961 catalogue for an exhibition at Gallery One, London, at the height of the Cold War, 'I use aesthetics instead of knives and bullets to protest against stuffed shirts and hypocrites.'

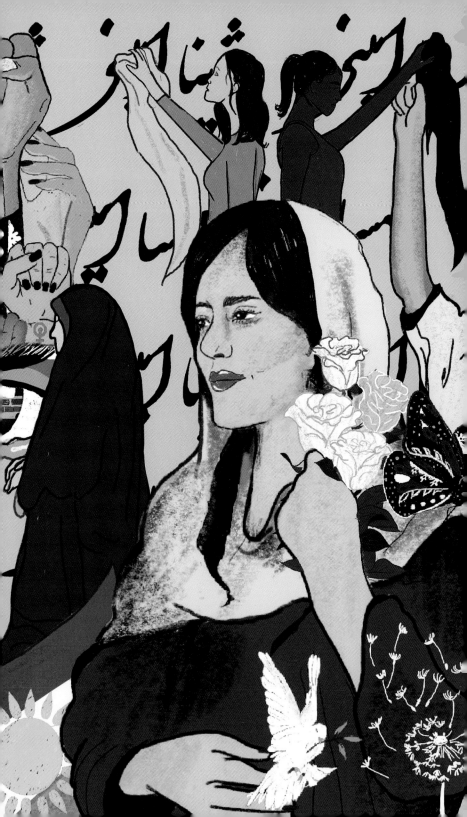

POLITICAL WEAPONRY

-

An artist acts in a political framework whether
he knows it or not. Whether he wants to or not.

-

Gustav Metzger,
Manifesto World, 1962

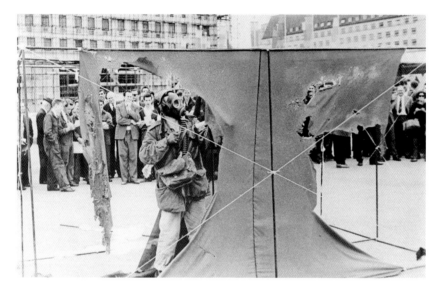

Gustav Metzger
practising for a public
demonstration of Auto-
destructive art using
acid on nylon, 1960.
Photograph possibly by
John Cox for Ida Kar.

'Auto-destructive art
re-enacts the obsession
with destruction' said its
inventor Gustav Metzger,
'the pummelling to
which individuals and the
masses are subjected.'

WHAT IS PROTEST ART?

In the early 1950s, a young German refugee living in a commune in Bristol, in the south-west of England, was confronted with a personal choice: move into revolutionary politics or become an artist. He chose the latter, believing that art can be a tool for social and political change. It was a strange time, in which the world seemed to be teetering on the edge of hysteria. Over the next seventy years Gustav Metzger became a one-man revolution, directing his art at what he described as the 'obscene present'.

If there is a thread running through Metzger's work, it is that modern society has gone badly wrong, becoming a place where humans have the capacity to engineer total obliteration. In 1959, as the world came perilously close to nuclear Armageddon, Metzger conceived of an art that destroyed itself, a faultless metaphor for the Cold War. He named it Auto-destructive Art and considered it to be a desperate, last-minute subversive political weapon.

The idea of art as a subversive political weapon will recur throughout this book. But what *is* protest art? Does it have a coherent definition? Can its aesthetic be easily summarized? Let's try. Protest art finds its space within political art and activist art. Political art tends to explore political subject matter without involving political action and is often made in direct response to an event. Activist art, on the other hand, is socially involved, seeks public participation and usually operates outside institutional structures.

Protest art finds its space within political art and activist art.

Protest art can be of the moment, giving voice to contemporary issues. It can be uncompromisingly precise, highlighting the concerns of marginalized or underrepresented groups, enabling citizens to speak truth to power in different ways. There is no definitive style or medium to protest art; it encompasses all aspects of the visual arts and most of it was never intended for a gallery setting. In the early twentieth century, performances, posters, leaflets, cartoons, collages, postcards and artist manifestos were relatively cheap forms of protest art, quick and easy to reproduce. Banners and placards served their purpose on picket lines and marches, while graffiti, murals and street art ensured political messages reached a wide audience.

During the 1960s, as technology became cheaper and easier to use, photography, film and video became the record and medium of protest art. In the twenty-first century's fluid, melting-pot world of image- and video-sharing, smartphones and social media, artists have found ways to employ various digital platforms to disseminate their message, harnessing the immediacy the medium brings. Crucially, the digital world has enabled artists to develop transnational alliances and coalitions with others who express similar concerns, such as the esprit de corps forged by the Black Lives Matter movement.

A CALL TO ARMS

There is generally an unequal balance of resources between protesters and the authorities they are opposing, and creatively inventive tactics are needed to persuade the public to join the dissenters. This is where art can be a great motivator. Here is the British suffragist and artist Mary Lowndes writing in *The Englishwoman* in 1909 about the power of a banner to inspire action:

> A banner is a thing to float in the wind, to flicker in the breeze, to flirt its colours for your pleasure, to half show and half conceal, a device you long to unravel, you do not want to read it, you want to worship it.

Lowndes understood the persuasive currency of the spectacle and how art and pageantry could be used as *gestalt* to swell the ranks of the suffrage movement. Resplendent banners bearing slogans such as 'Dare to be Free' and 'Rebellion to Tyrants is Obedience to God' contributed to a grand theatre of emotion.

-

There is generally an unequal balance of resources between protesters and the authorities they are opposing, and creative tactics are needed.

-

The Suffragettes were particularly adept at employing humour to disarm their opponents and generate support. They understood that injustice is reinforced by visual language, so mimicked the language and imagery of government to make visible the absurdity of their situation. Emily Harding Andrews's poster *Convicts, Lunatics*

Mary Lowndes
Spiritual Militancy, 1907–1922.
Pencil and orange and black watercolour on paper, 17.4 x 10.2 cm (6⅞ x 4⅛ in.)

Banner design worked by the Artists' Suffrage League, commemorating early supporters of women's suffrage, carried in the 13 June 1908 National Union of Women's Suffrage Societies procession. The Artists' Suffrage League was founded in 1907 by professional women artists in order to create eye-catching banners, posters and postcards to further the cause of women's suffrage. The banners were considered a great success on marches, creating a medieval festival atmosphere and helping to raise awareness.

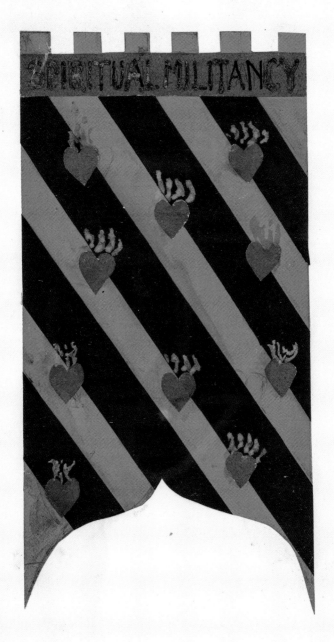

62

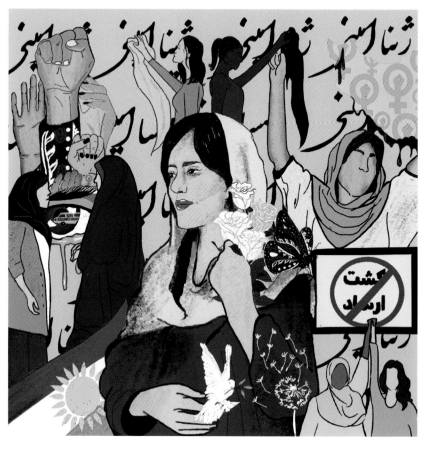

Sahar Ghorishi
Jina Mahsa Amini – for Women, Life, Freedom, 2022

The London-based Iranian digital artist Sahar Ghorishi uses her platform Journey of/to Dawn to give voice to those unable to speak out, recounting the stories of women protesters living in the Middle East and North Africa. On 16 September 2022, 22-year-old Iranian woman Jina Mahsa Amini was severely beaten by the religious morality police and died in a hospital in Tehran. She had been arrested for allegedly not wearing the hijab. Amini's death lead to widespread protests and ignited the Women, Life, Freedom protest movement, which demands the end of oppression and discrimination against women in Iran.

and Women! Have No Vote for Parliament (1910) depicts a female graduate behind bars, saying, 'It is time I got out of this place. Where shall I find the key?' The group also exploited religious imagery to promote the idea that women's suffrage was consistent with virtue and honour. The artist Sylvia Pankhurst, daughter of the Suffragette founder Emmeline Pankhurst, designed the Women's Social and Political Union (WSPU) angelic herald motif, and a picture of a barefoot woman leaving a prison accompanied by a flock of doves.

Such emotive imagery was also adopted by later feminist groups. The anarchist collective Mujeres Libres (Free Women of Spain), which emerged during the Spanish Civil War (1936–39), used similar crusading tactics to fight for an egalitarian society. The statement 'Let no one without imagination, without intuition, without inspiration become a teacher!' appeared in their publication *Mujeres Libres* in 1937. The essential tenet of the group was the need to think creatively, like artists, in order to change society, especially in relation to educating children about women's equality.

**The essential tenet of the group was the need
to think creatively, like artists.**

During the violent military dictatorship of General Augusto Pinochet in Chile in the 1970s and 1980s, when more than 3,000 people were 'disappeared' – secretly tortured and murdered by the state – women devised a highly effective form of protest to articulate and document the unspeakable tragedies happening to them, and to disarm their oppressors of their power to silence them. Made in women's workshops run by the Roman Catholic Church, which opposed the regime, *arpilleras* are brightly coloured patchwork quilts featuring scenes of life under Pinochet. They show communal kitchens and queues for food, torture and the brutal repression of popular protests. The textiles were distributed and shown overseas by the Church and evoked outrage and compassion from an international public.

Craft also featured prominently in the Women's Peace Camp on Greenham Common in south-east England in the 1980s. Artists embroidered banners and draped knitting and crochet over the fences of the Royal Air Force station in protest against the storage of NATO nuclear missiles on British soil. The handmade humanity of the artworks stood in contrast to the deadly warheads and covert

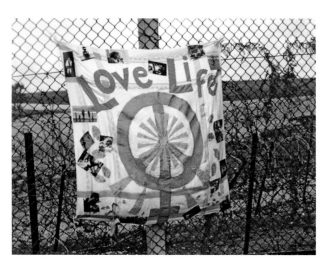

Bridget Boudewijn
Women's Peace Camp
Greenham Common,
1981

Somewhat ironically,
Newbury District
Council tried to evict
the Greenham Common
protesters on the grounds
that the peace camp was
an environmental health
hazard (as opposed to the
'sanitized' nuclear base
next door).

Cold War psychology behind the wire fences. 'Never before has the use
of embroidery so clearly demonstrated the place of art in the splitting
that structures and controls our society – and may one day destroy us,'
wrote the art historian Rozsika Parker in *The Subversive Stitch* in 1984.

A year later, AIDS activists in San Francisco conceived of a quilt
to commemorate the more than 1,000 fellow citizens who had died
from AIDS-related illnesses. As word spread, further names and
more panels were added to the work. In 1987, the quilt was unfurled
during the National March on Washington for Lesbian and Gay
Rights, when the names of those who had died were also read out.
Panels continue to be added; in 2020, the AIDS Memorial Quilt
included dedications to almost 110,000 people.

A MEMORABLE IMAGE
In 1906, while visiting England, Mohandas K Gandhi witnessed a
street protest by the Suffragettes. Commenting on the event in
the *Indian Opinion* newspaper, he wrote:

> Today the whole country is laughing at them, and they have only
> a few people on their side. But undaunted, these women work on
> steadfast in their cause. They are bound to succeed and gain the
> franchise, for the simple reason that deeds are better than words.

Twenty-four years later, Gandhi set off on a 241-mile march
to Dandi, on the west coast of India, as a demonstration of defiance
against British colonial laws. This was Satyagraha, a non-violent

Nandalal Bose
Bapuji, c. 1930
Linocut print on paper,
35 × 22.3 cm (13¾ ×
8⅞ in.)

The success of this
linocut of Gandhi is down
to the dramatic use of
deep lines and shadows.
You can sense the nerves
and bones beneath the
surface of the body –
almost like an X-ray.
Its simplicity echoes
religious iconography.

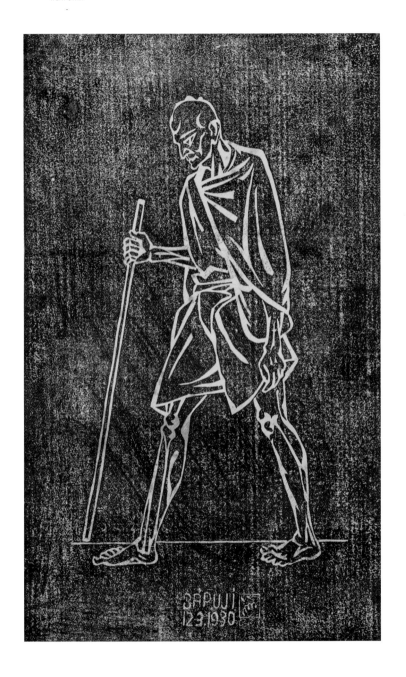

civil disobedience movement. Gandhi was the architect of non-cooperation, a new mode of anti-colonial politics. He believed that peaceful and passive resistance could bring about political change. The results were extraordinarily effective. Through marches, hunger strikes and non-violent protest, the civil disobedience movement showed Britain and the British for what they really were: a coercive colonial state and the perpetrators of oppression.

One of the key unifying elements of the Satyagraha movement was a portrait of Gandhi by the artist Nandalal Bose, which was reproduced on flyers and posters and distributed along the Dandi march. The linocut depicted Gandhi wearing a homespun loincloth and blanket. The image circulated in India and abroad, cementing Gandhi's saint-like image in the public imagination.

Gandhi's portrait has remained a potent image for Indian artists, particularly as sectarian violence in the country increased in the 1990s and 2000s. The demolition of the Babri Masjid mosque in 1992 by right-wing Hindu nationalists and the subsequent riots and bomb blasts in Mumbai, in which hundreds died, prompted the artist Atul Dodiya to highlight the hypocrisy of contemporary Indian society through a series of photorealistic paintings based on photographs documenting Gandhi and the nationwide Quit India movement. The artist incorporated the creasing and flecking of the original photographs and added gestural planes of colour taken from the abstract paintings of the Indian nationalist Rabindranath Tagore.

Many artists have instinctively understood the importance of a leader's image for creating a powerful visual mythology.

Emory Douglas
African American solidarity with the oppressed People of the World, poster in *The Black Panther*, 1969
Offset lithograph on paper, 57.8 x 37.5 cm (22⅞ x 14⅞ in.)
Victoria and Albert Museum, London

Douglas was influenced by the writings of Frantz Fanon, who emphasized the importance of culture to solidify a collective national consciousness. His graphics captured the imagination of a new generation of African-American activists who saw their struggle as part of a wider effort to fight imperial oppression across the world.

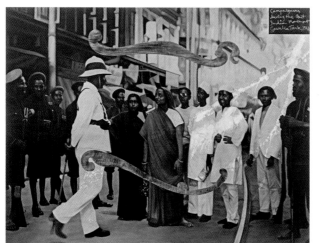

Atul Dodiya
Campaigners during the Quit India Movement, Gowalia Tank – 1942, 2015
Mixed media: oil, acrylic with marble dust and oil-stick on canvas, 182.9 x 243.8 cm (72 x 96 in.)

This painting features an important site in the history of Indian independence. Gowalia Tank was where, on 8 August 1942, Mahatma Gandhi delivered his 'Quit India' speech, which ignited a nationwide civil disobedience movement.

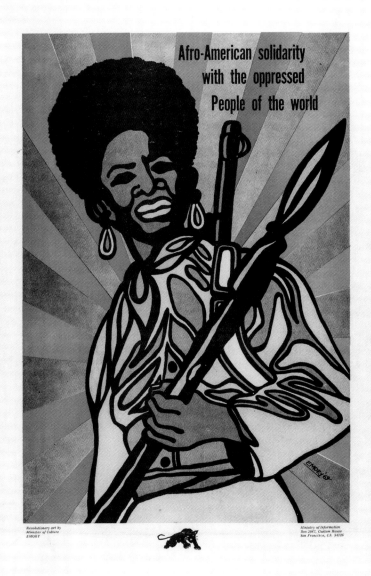

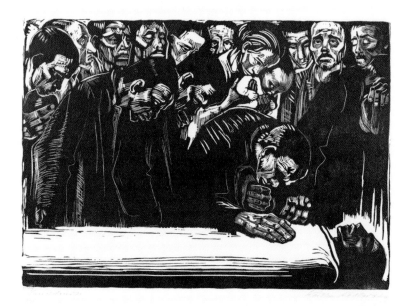

Emory Douglas served as the Minister of Culture in the Black
Panther Party from 1967. His role was to shape the image of its
co-founders Bobby Seale and Huey P. Newton as revolutionary
leaders prepared to defend themselves to the death, and to
communicate the party's ideology before others, such as the
mainstream media, did it for them. To this end, Douglas's posters
combined a simple, eye-catching style with hard-hitting slogans
such as 'All Power to the People' and 'Seize the Time!'

Other Civil Rights protest posters spoke to the oppressors,
but Douglas directed his images at the Black community. 'His
drawings gave visible form to the bold ideas of revolution we were
kicking around in those days,' writes the political activist Kathleen
Cleaver in *Black Panther: The Revolutionary Art of Emory Douglas*
(2007). He also portrayed the hardships experienced by the Black
community; in the same book, Black Panther leader Eldridge
Cleaver described Douglas's work as 'an essential cultural weapon
in the struggle for liberation'.

One of the most influential artists to understand the power an
image could have was the committed social democrat Käthe Kollwitz,
who put her art to the cause of political change in pre-war Germany.
The wife of a doctor who ran a clinic in the working-class Berlin

Käthe Kollwitz
*In Memoriam Karl
Liebknecht (Memorial for
Karl Liebknecht)*, 1920
Woodcut, printed in
black ink on thick Japan
paper, 48 x 60 cm (19 x
23⅝ in.)
Getty Research Institute,
Los Angeles

**Kollwitz knew the
socialist leader Karl
Liebknecht, who in
1918 led the Spartacist
uprising in Germany.
He and his Spartacus
League co-founder
Rosa Luxemburg
were murdered soon
afterwards by the state
intelligence services.**

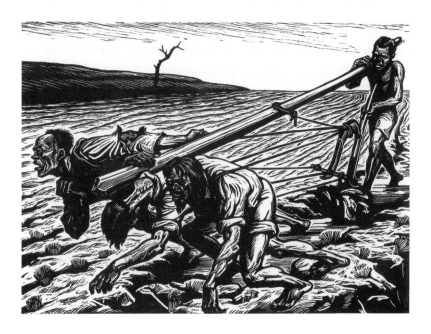

Li Hua
Raging Tide I: Struggle,
1947
Woodblock print; oil-
based ink on paper, 19.5 x
27 cm (7¾ x 10⅝ in.)
British Museum, London

Li Hua was a leading
member of the Chinese
woodcut movement,
which took inspiration
from the work of the
German Expressionist
Käthe Kollwitz. Li was
a friend of Lu Xun, and
established the modern
woodcut society at the
Guangzhou School of Art.

neighbourhood of Prenzlauer Berg, Kollwitz saw at first hand the
terrible social deprivation caused by Germany's rapid industrialization
at the turn of the century. She hoped to bring the plight of the
poor to the attention of society through her pictures of hunger
and despair. 'It is my duty to voice the sufferings of humankind, the
never-ending sufferings heaped mountain high. This is my task, but
it is not an easy one to fulfil,' she wrote in her diary in 1920.

**Kollwitz hoped to bring the plight of the poor to
the attention of society through her pictures.**

Kollwitz favoured printing for its dramatic effects, appreciating
the deep shadows and striking contrasts created by using black ink
on white paper. That graphic sensibility helped to cement the artist's
reputation as, in the words of French writer Romain Rolland, 'the
voice of the silence of the sacrificed'. But her images also conveyed
a spirit of resistance born out of her activities as a prominent
member of the left who tried to improve the living conditions of
the workers.

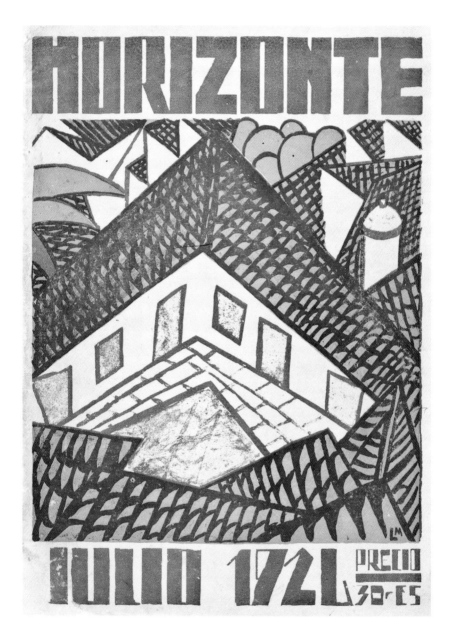

Leopoldo Méndez
Horizonte no. 4, volume
1 (front cover), Mexico,
July 1926
29 x 21.5 cm (11½ x
8½ in.)
Museo Nacional de Arte,
Mexico City

Horizonte **was the
mouthpiece of the
Stridentists, a politically
active avant-garde
group formed in post-
revolutionary Mexico in
the early 1920s. Its ten
issues were edited by
the revolutionary poet
Germán List Arzubide.**

Kollwitz was a key inspiration for the woodcut movements that proliferated in China in the mid-1930s. Her aesthetic was promoted by the celebrated essayist Lu Xun, famous for his existential novel *The True Story of Ah Q* (1921–22). A merciless critic of Chinese society, Lu had issued a call for reform in 1936. He recognized that the quickest way to disseminate ideas was through pamphlets and prints in the Chinese street vernacular that could be understood by all. He established and financially supported societies of woodcut artists in Shanghai, Hangzhou and Beijing. The images produced by these workshops were raw and gestural, depicting peasants striving against harsh conditions.

Images critiquing social injustices were utilized by many radical artist-activists in the 1920s and 1930s. In Mexico, the Estridentismo (artists of Stridentism), founded by the dynamic poet Manuel Maples Arce, agitated for a better world through murals, woodcuts and pamphlets. In Croatia, the short-lived Zemlja (Earth) artists' collective rejected painting and idealized images of peasant life for social realism, believing that they could instigate a revolution through the accurate representation of oppression.

KEY QUESTION
What are the most effective tools used by artists to protest?

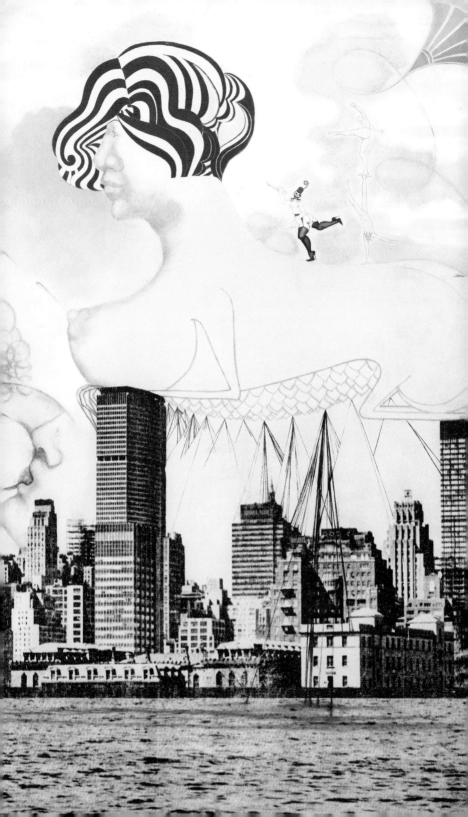

SATIRE AND ABSURDISM

-

The new artist protests: he no longer paints

-

Tristan Tzara,
Dada Manifesto, 1918

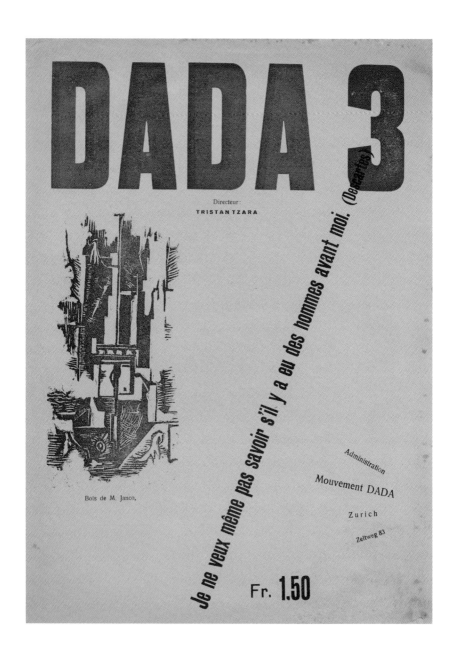

DADA 3

Directeur:
TRISTAN TZARA

Bois de M. Janco.

Je ne veux même pas savoir s'il y a eu des hommes avant moi. (Descartes)

Administration

Mouvement DADA

Zurich

Zeltweg 83

Fr. **1.50**

Tristan Tzara
Movement Dada (front cover), c. 1917
33.7 x 24.6 cm (13¼ x 9¾ in.)

Tristan Tzara was one of the founding figures of Dada. He recognized the abstract potential of language as a new art form. The Dadaists were disgusted by bourgeois culture, which they held responsible for the First World War. They wanted to create a new, iconoclastic culture that examined language from the viewpoint of politics, noise and absurdism.

A BUFFOONERY AND A REQUIEM MASS

In the spring of 1916, a disparate group of Romanian and German exiles gathered in the small underground bar of the Cabaret Voltaire in Zurich. They had congregated to call into question the values of a supposedly civilized and rational society that was prepared to accept the mass slaughter of its youth. They used nonsense, noise, photomontage and chaos to repudiate war in a manner that was bewildering but intellectually stimulating.

This was Dada – a tiny, satirical group of left-leaning artists that emerged in Switzerland in reaction to the horrors of the First World War. The art they produced was shocking and irrational, and attacked what they saw as the lies and emptiness of high culture. Their ringleader Hugo Ball, along with his fellow poets Richard Huelsenbeck, Marcel Janco and Tristan Tzara, chanted absurd verse while wearing peculiar costumes. It was, to quote Ball in 'Dada Fragments' (1916), at once 'a buffoonery and a requiem mass' for a world that sent its young to die in battle.

Out of these performances came the *Dada Manifesto*, written by Tzara. It defined Dada's anarchic vision as 'nothing', 'futile', an 'abolition of logic'. The poet considered the figure of the Dadaist to be one who embodied the traumas of the times 'to the point of disintegration'.

Much of Dada's tone and rhetoric came from the German philosopher Friedrich Nietzsche, whose declaration of the death of God resonated with these young cultural activists. The philosopher had written in his semi-autobiographical *Ecce Homo* (*Behold the Man*, 1908) that he would rather be a buffoon than a holy man, a perspective reflected in Dada's absurdist humour.

Much of Dada's tone and rhetoric came from the German philosopher Friedrich Nietzsche.

After the First World War, the focus of Dada switched to Berlin, where the German Dadaists George Grosz and Otto Dix turned their scorn on the Weimar Republic by attacking its failings in satirical drawings and paintings. The Berlin Dadaists established a Central Council of Dada for the World Revolution to protest at the Weimar National Assembly. The writer Johannes Baader hurled flyers bearing the slogan 'Dadaists against Weimar' at the politicians. Dadaists joined the newly formed German Communist Party, participated in the workers' strikes that followed the assassination of the communist

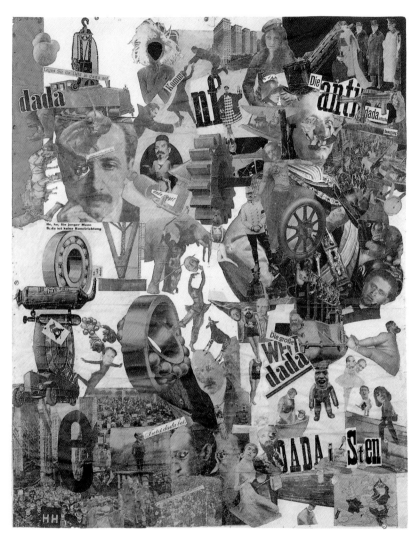

Hannah Hoch
*Cut with the Kitchen
Knife Dada Through
the Last Weimar Beer-
Belly Cultural Epoch
in Germany*, 1919–20
Photomontage, 114 x
90 cm (44⅞ x 35½ in.).
Nationalgalerie,
Staatliche Museen, Berlin

Hannah Hoch was
a member of the
Novembergruppe, which
hoped to reform art
schools and museums
after the Spartacist
uprising. Her collages
used a mass of cultural
imagery and mixed
male and female bodies
together to question
gender identity, desire
and consumerism.

leaders Rosa Luxemburg and Karl Liebknecht, and set up the Rote Gruppe (Red Group) to organize and mobilize radical artists in the service of a revolution in Germany.

The artists' ferocious aesthetic was epitomized by their use of collage, a medium so brittle and fractured it was perceived as an anarchistic attack on fine art. Its visual language seemed capable of expressing something disturbing and unpalatable about the world we live in: Hannah Höch's collage *Cut with the Kitchen Knife Dada Through the Last Weimar Beer-Belly Cultural Epoch in Germany* (1919–20) sliced up the patriarchal world order and refigured a new one that gave prominence to women, while Raoul Hausmann and John Heartfield lampooned the corruption of German politicians and industrialists. They would later turn their obstreperous anger on

John Heartfield
Goering the Executioner,
14 September 1933
Photomontage, 42 x
29.3 cm (16½ x 11½ in.)
Akademie Der Künste,
Berlin

John Heartfield was born Helmut Herzfeld in 1891 but changed his name in protest at the nationalism that was to bring Hitler to power in 1933. Much of his art appeared in left-wing magazines that satirized Nazi policies. In this image, Herman Goering is depicted as the architect of the Reichstag fire, in which the government legislative building was burned to the ground.

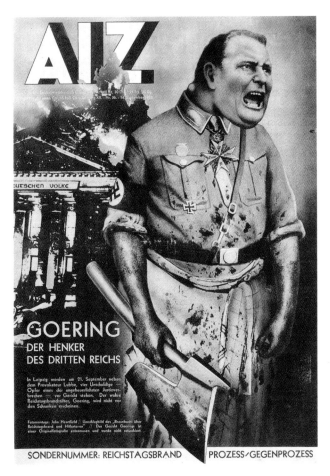

the Nazi Party, portraying Adolf Hitler and Hermann Goering as monstrous grotesques in satirical photomontages.

Dada's shocking humour was supposed to shake society out of somnambulism into revolution, and it continued to be an unruly influence. It can be found in the interdisciplinary performances of Fluxus, an international art movement in the 1960s, such as Philip Corner's *Piano Activities* (1962), in which a piano is destroyed, and the ninety cans of artist's shit sold by Piero Manzoni in 1961 in protest at the corporatization of the art world. It can also be found in Punk and Post-Punk – in the sociopolitical tumult of Linder's magazine collages and Peter Kennard's satirical montages in protest against war and human rights violations, perhaps most famously *Tony Blair ('Photo Op')* (2005), made with Cat Phillipps, which depicts the then UK Prime Minister Tony Blair taking a selfie in front of an airstrike in Afghanistan. Kennard considers his art a visual tool, to be used by people in their political struggles

Piero Manzoni
Artist's Shit, 1961
Tin can, printed paper and excrement, 4.8 × 6.5 × 6.5 cm (2 x 2⅝ x 2⅝ in.)
Tate, London

Made in an edition of 90, each can was sold by weight at gold's daily market price: the shit was worth its weight in gold. Since 1991 the artwork has outperformed gold in price more than 70 times.

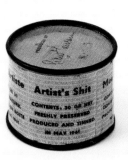

Linder
*Untitled (Woman
poking her eyes out
with a fork)*, 1976
Printed papers on
paper, 27.9 x 19.6 cm
(11 x 7¾ in.)
Tate, London

**Dada's spirit can be seen
in the punk cut-ups
created by Linder, who
used collage to provoke
the establishment. 'You
make things wrong
to make things right,'
she has said of her
provocative aesthetic.**

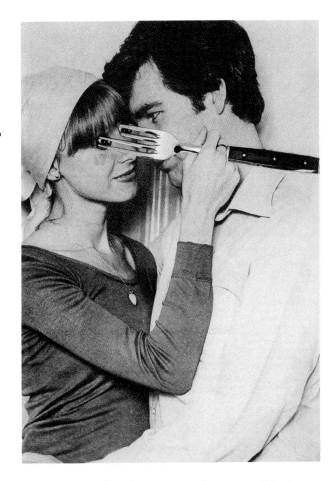

against authority: 'It is about people acting in the world rather
than sitting back and thinking they can't do anything,' he said in
an interview at Tate Britain in 2011.

Art makes a crisis visible. In 1970, a collage in the counterculture
magazine *Oz* seemingly shocked the British establishment so much
that three men were put on trial for obscenity and the corruption
of minors. The editors Jim Anderson, Felix Dennis and Richard
Neville had printed a collage that pasted the head of the much-loved
children's character Rupert Bear (the mascot of the *Daily Express*
newspaper) onto a sexually explicit cartoon by Robert Crumb. It
appeared in the 'School Kids Issue' of the magazine, which had
been guest-edited by teenagers. As the defendants awaited trial,
artists outraged at the charges and the hypocrisy (the Metropolitan
Police's Obscene Publications Squad had relentlessly pursued the

Richard Jim

Felix

David Hockney
*Portrait of Richard Neville,
Jim Anderson, Felix
Dennis*, 1971
Lithograph, edition
of 30, 71.1 x 95.3 cm
(28 x 37½ in.)
National Portrait
Gallery, London

**Hockney's etching
depicts the three
defendants in the 1971
Oz trial. They were
prosecuted under the
charge of conspiracy to
corrupt public morals,
which carried a maximum
sentence of life
imprisonment.**

Statement on Censorship by Anita Steckel (woman artist)

We women artists —

We believe — sexual subject matter should be removed from the "closet" of the fine arts where it resides in small portfolios, small works, off the walls, in private collections, etc. We believe sexual subject matter includes many things: political statements, humor, erotica, sociological + psychological statements — as well as purely sensual or esthetic "art" concerns — and of course — the primitive, mysterious reasons none of us know.

Sexual subject matter is kept by museums + in "smut" magazines, films, etc. — by men still in power — because it is considered too unwholesome for such "high places."

Nude + sexually portrayed women, however are not kept out of museums. It is always the men who cover their sex — who hide what they consider "their shame" — who think of their sexuality as unwholesome — the "fig leaf tradition".

We women artists object to this unhealthy + sexist discrimination + we demand an end to past sexist puritanism in museums. We assert that sexual as well as any other subject matter is entirely the artists concern + the museums have no right to impose their puritanical + sexist — unbalanced — therefore unhealthy timidity + coyness upon us all + upon future generations — + we demand that sexual subject matter — as it is part of life — no longer be prevented from being part of art. And since — the woman has traditionally been exposed in her full nakedness + sexuality in all the great museums of the world - so should the male be uncovered — as sexually on display as the woman — and the erect penis, therefore, as it is part of life — no longer be prevented from being part of art. If the erect penis is not wholesome enough to go into museums — it should not be considered wholesome enough to go into women.

And if the erect penis is wholesome enough to go into women — then it is more than wholesome enough to go into the greatest art museums.

distributed to other women artists — on march 8, 1973 in N.Y.C.

Anita Steckel

Anita Steckel
Fight Censorship
manifesto, 1973
27.9 x 21.6cm
(11 x 8⅜ in.)

The all-female Fight Censorship group challenged institutional double standards with satire.

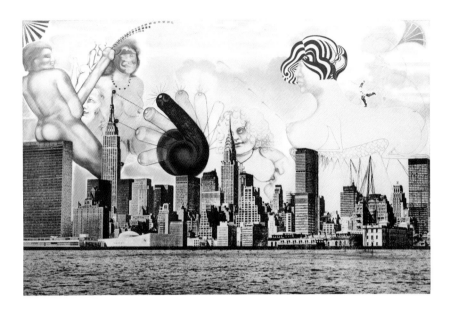

Anita Steckel
NY Canvas Series 2, 1971
Screenprint and oil on
canvas, 162.6 x 251.5 cm
(64 x 99 in.)

**Giant women and penises
cavorting across the
New York skyline: Anita
Steckel's witty collages
embraced the anarchic
energies of the Beat
generation, but from a
feminist perspective.**

editors while allowing the owners of pornographic bookshops to
continue operating in return for regular backhanders) got together
to raise money for the defence by auctioning artworks. Among
those enraged at the absurdity and viciousness of the law was David
Hockney, who produced a limited-edition lithograph of the three
defendants naked. John Lennon, who had only recently had charges
of obscenity dropped following an exhibition of erotic lithographs at
the London Arts Gallery, wrote the song 'God Save Oz'.

In 1973, the jagged currency of censorship was rendered in
absurd new syntax by the American artist Anita Steckel, in response
to attempts to shut down an exhibition of her collages entitled
'The Sexual Politics of Feminist Art'. The authorities objected to
the depiction of erect penises. Steckel protested, writing a response
that both outlined the sexist discrimination of art institutions and
mounted a hilarious defence of the penis in art. Her piece ended:

> If the erect penis is not wholesome enough to go into a museum,
> it should not be considered wholesome enough to go into
> women. And if the erect penis is wholesome enough to go into
> women – then it is more than wholesome enough to go into the
> greatest art museums.

Humorous placards are the medium of the contemporary artist
Bob and Roberta Smith, who has taken on the British government

Bob and Roberta Smith
Art is Your Human Right,
2018
Screenprint on paper,
68.5 x 52 cm (27 x
20½ in.)

The veteran artist activist has protested cuts in funding for art in schools throughout the 2010s and 2020s. In 2014, he organized a UK-wide Art Party, based around screenings of his film of the same name, to promote the importance of art in education.

over art education policy. In 2015 the artist stood for election against Conservative education secretary Michael Gove in order to resist what he saw as the marginalization of art in schools and cuts in funding for art materials. A lifelong protester who paints slogans on scrap timber, Smith has staged agitprop happenings, ad-hoc drawing classes and even an alternative party political conference as a way of highlighting the denigration of the arts by recent UK Conservative governments. Smith thinks that creativity helps embolden protest. In the *Guardian* in 2012, he cited the political theorist Hannah Arendt, who believed in the capacity of people to reinvent themselves through politics:

> Make your own damn banners, put images of them online, dress up, dress down, perform and inform. Tell the government and those around you what YOU think of their hopeless, mindless austerity.

Bangkok, Thailand. March from the front of Bang Khen Fire Station towards 11th Infantry Regiment, with yellow duck dolls joining the parade, 29 November 2020.

The cartoon energy of the 2020 pro-democracy protests in Bangkok, in which protesters carried large inflatable rubber ducks, served to undermine authority and protect protesters from police violence.

LONG LIVE RUBBER DUCKS!

In 2007, in an essay titled 'On the Phenomenology of Giant Puppets', the American anthropologist David Graeber observed that 'the forces of order in the United States seem to have a profound aversion to giant puppets'. The image of a giant inflatable

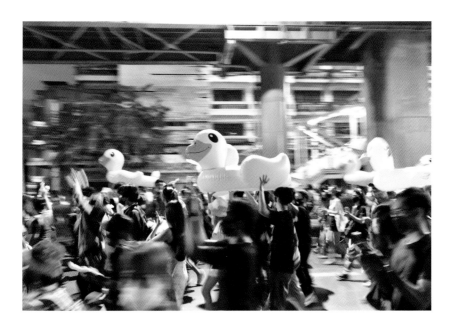

sculpture bobbing on the front line of a mass demonstration has
become ubiquitous in the twenty-first century. The bright orange
baby Donald Trump that appeared during protests against the US
president's visit to the UK in 2018 and the giant rubber ducks
that have become a symbol in Thailand's pro-democracy protests
since 2020 have been used variously to mock the authorities and
to protect protesters from police violence. Gavin Grindon, who in
2014 curated an exhibition of protest objects at the Victoria and
Albert Museum in London, said in an interview with the *Guardian*:

> The police just don't know what to do with things like this.
> Do they throw the inflatable back, in which case they're
> engaging in this weird performance? Do they try to bundle it
> into a van? Or do they try to attack it and deflate it?

Ruminating on why these giant mascots create so much fury,
Graeber wrote that perhaps their ephemerality makes a mockery
of the 'very idea of the eternal verities that monuments are meant
to represent'. In the aftermath of the police crackdown on Thai
anti-government demonstrations, protesters took to social media
to praise the bravery of the rubber ducks, further humiliating and
undermining the authorities. As the Hong Kong activist Joshua
Wong said on Twitter: 'Creativity wins, long live rubber ducks'.

In the late 1960s such ideas were very much part of the radical
Italian architects' collective Gruppo UFO, who created a series of
inflatable sculptures for mass protest. They named their rocket-
shaped inflatables *urboeffimeri* (urban ephemera) and emblazoned
them with anti-capitalist and anti-imperialist messages such as
'Colgate con [with] Vietcong'. In 1973, members of the group founded
the Global Tools collective as a reaction against the conservative
teaching of architecture in Italian universities. During a period of deep
political crisis in Italy, Global Tools invented new ways of examining the
urban environment as a space of civic demonstration and exploration
and encouraged students to question the role of the architect in
relation to state and corporate power. These provocations influenced
the Dutch Eclectic Electric Collective, who in 2010 made light, easy-
to-pack inflatable sculptures that could be sent on demonstrations
across the world. Their first inflatable was a giant silver hammer
inspired by Leon Trotsky's statement in his 1924 essay 'Literature and
Revolution': 'Art, it is said, is not a mirror, but a hammer: it does not
reflect, it shapes.' It was sent to the Mexican activist group Marea
Creciente (Rising Tide) for use in protesting the ineffective policies of
the 2010 United Nations Climate Conference in Cancún.

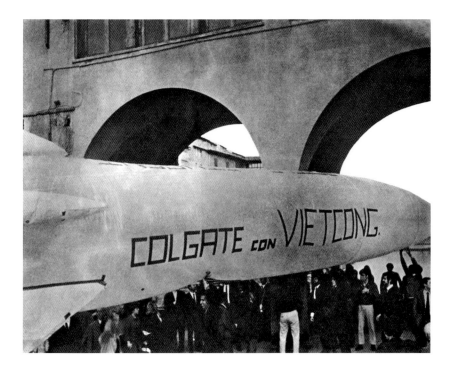

Gruppo UFO
Urboeffimero n. 5
(Florence, Italy, 1968).
From *Marcatré* 41–42
(1968)

The experimental
Gruppo UFO performed
several happenings in
1968 in which they
invited students to
construct large tubes for
demonstration. The slogan
'Colgate con Vietcong'
made the connection
between corporate and
American imperialism.

INSURRECTIONARY IMAGINATION

All too often protest art can find itself preaching to the converted;
it needs to find a message that can bridge divides and change
people's minds. One of the most dispiriting aspects of the protests
against the recent presidencies of Jair Bolsonaro in Brazil and
Donald Trump in the United States was their impotence in the
face of administrations happy to swamp the public discourse with
lies. In such circumstances, new tactics are required, ones that
work in surprising and unforeseeable ways. This is where the artistic
imagination can help.

ACT UP is a direct action group founded by radical gay rights
activists in New York in 1987 to challenge government inaction over
the ongoing AIDS crisis. Like the early twentieth-century women's
suffrage movement, the organization was media-savvy, developing
performance strategies to gain media attention. Protests were held
at tourist sites such as the Statue of Liberty, and in 1989 members
of the group infiltrated the New York Stock Exchange, letting off
foghorns and chaining themselves to a balcony in protest at the
high cost of the drug AZT, which was used to treat people with
AIDS-related illnesses. ACT UP ensured that their performances

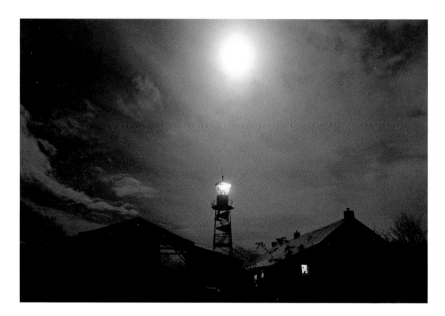

were well documented and the photographs made available for national newspapers. Artists were key in helping to disseminate the group's information through flyers, zines and posters, including the 'Silence=Death' graphic. Out of these activities emerged Gran Fury, a graphic arts collective that adopted the eye-catching methods of advertising to get their messages noticed. Their guerrilla marketing campaigns were instrumental in generating public awareness and debate.

-

All too often, protest art can find itself preaching to the converted.

-

Isabelle Fremeaux and Jay Jordan are the Laboratory of Insurrectionary Imagination. Under this name they devise ingenious ways to protest against inaction over climate change. In 2005, they toured Britain recruiting environmental activists for their carnivalesque Rebel Clown Army to demonstrate at the G8 summit of the world's wealthiest industrialized nations in Scotland. Since then, they have become deft facilitators of witty and media-friendly antics, including a Fluxus-inspired game during the United Nations Paris Climate Change Conference of 2015, in which 124 teams tried to outperform each other for the funniest and most audacious direct action against climate criminals.

The Laboratory of Insurrectionary Imagination
The illegal lighthouse against an airport and its world, 2016

To stop the proposed development of an airport near Notre-Dame-des-Landes in Brittany, a lighthouse was constructed out of an old electricity pylon, enabling protesters to lock themselves to the metal structure to avoid its destruction.

MAKE NIETZSCHE YOUR PRINCIPAL GUIDE

In Japan in the early 1900s, a febrile atmosphere of dissent fuelled by anarcho-communists sympathetic to the Russian Revolution inspired left-leaning artists into acts of revolt. Perhaps the most infamous was Mavo, founded in 1923 out of frustration at the stultifying restrictions placed on Japanese art education. Mavo's leader, the avant-garde artist Tomoyoshi Murayama, had recently returned from Weimar Berlin and saw in the spirited anarchism of Tokyo's young intelligentsia similarities with Dada and Futurism. He developed the concept of 'conscious constructivism', the idea of an art that was non-objective or abstract and celebrated creativity. 'Make Nietzsche your principal guide,' he ordered; he was also keen on Schopenhauer's philosophy of the artist as genius.

During 1923, Mavo launched a series of rabble-rousing performances that mocked Japanese society and argued for a free and expressive art. They used the press to promote their message – something Murayama described as putting 'hypocrisy on the front page' – and founded a magazine to promote their artistic agenda. It began with a suitably declamatory assertion:

Mavo is a group of completely blue criminals who wear completely black glasses on their completely red faces. Lazily, like pigs, like weeds, like the trembling emotions of sexual desire, we are the last bombs that rain down on all the intellectual criminals (including the bourgeois cliques) who swim in this world.

Like the Italian Futurists, Mavo believed that a revolution was needed to sweep away the old order. When the Great Kantō Earthquake hit Tokyo in September 1923, killing thousands and devastating the city, Mavo artists took to the streets, performing among the wreckage in cafés and parks, staging ad-hoc exhibitions and joining forces with other artists to help reconstruct the city. Their radical reign was, however, brief. By 1925, Mavo had disbanded as a result of censorship and police intimidation. Murayama and fellow Mavoist Yanase Masamu were arrested, as were their colleagues, the high-profile anarchists Noe Itō and Sakae Ōsugi, who were later murdered by the police. The survivors resumed their dynamic cultural anarchism on their release from jail, but by 1926 conflicting left-wing ideologies had forced a further split in the group. Murayama continued to agitate for a revolution and between 1930 and 1945 he was often imprisoned.

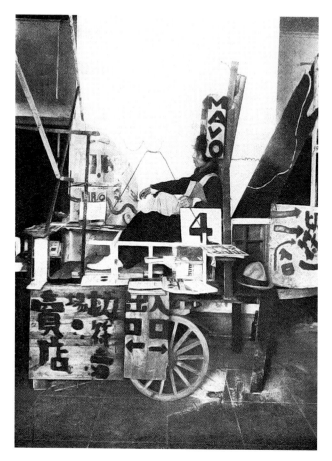

Mavo
Installation view of Okada Tatsuo seated in *Gate Light and Moving Ticket Selling Machine*, 1925. Displayed at the entrance to the Second Sanka Exhibition at the Jichi Kaikan, Ueno Park, Tokyo, in September 1925

When Mavo artists were rejected by the jury of the Imperial art exhibition in 1925 because of their supposedly transgressive behaviour, the artists devised their own mobile *salon des refusés* outside the exhibition hall in Ueno Park, Tokyo.

-

Mavo believed a revolution was needed to sweep away the old order.

-

It was not until the 1950s, during a time of deprivation in Japan and a very specific post-war cynicism, that Mavo's Dadaist sensibilities were reignited. Widespread demonstrations against the US military presence in the country erupted on the streets of Tokyo; although many of the artists and photographers participating in the protests were too young to have felt the direct effects of military defeat in the Second World War, they were acutely sensitive to the country's continued impoverishment.

Several groups emerged at this time, among them the short-lived Neo-Dada Organizers, a provocative outfit who presented themselves as an unruly, anarchic force through public performances that generally contained some form of destructive act. The invitation to their first exhibition in 1960 contained the singular statement:

As seriously as one might dream of procreation in 1964, a single atomic bomb can cheerfully solve the problem. Picasso's [painting of a] bull fight cannot impress us so much as blood gushing forth from a stray cat run over by a car. Being, as we are, on the stage of this red-faced Earth in the 20.6th century, the only means for us to avoid being massacred is to become destroyers ourselves.

One of Neo-Dada's founders, Genpei Akasegawa, went on to establish the direct-action group Hi-Red Centre, whose performances included *Cleaning Event*, staged during the 1964 Tokyo Olympic Games in protest at the Japanese government's attempts to 'clean up' the city and relocate the homeless. The artists ridiculed the government's endeavours by scrubbing the streets with cotton wool and ammonia. Other absurdist performances included *Shelter Plan* (also 1964), in which the group proposed creating one-person nuclear bomb shelters. Their antics were closely followed by the artist collective Zero Dimension, who in the late 1960s paraded naked through the streets of Tokyo wearing gas masks as a form of 'ritual', disrupting everyday life.

KEY QUESTION

How does protest art use humour and disruption to change society?

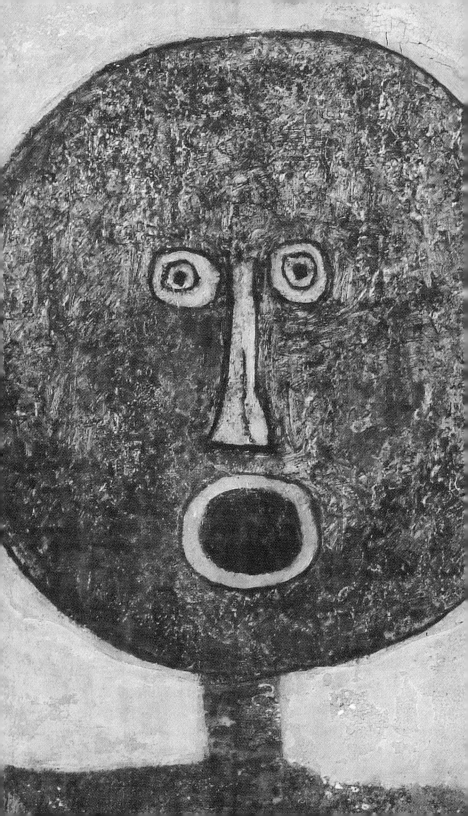

ART AND FREEDOM

Freedom against terror in all its forms.

Georges Henein, Manifesto, 1945

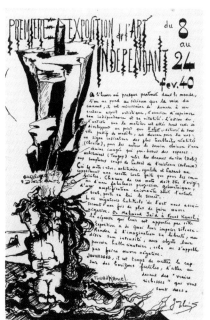

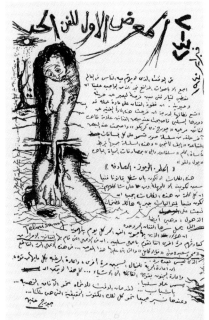

Art et Liberté
Front and back covers,
catalogue for the
first 'Art et Liberté'
exhibition, 1940, with
text by Georges Henein
and drawing by Kamel
el-Telmissany and Fouad
Kamel
25 x 16.3 cm (9⅞ x
6⁴⁄₈ in.)

In 1938 André Breton and
Leon Trotsky created the
International Federation
of Independent
Revolutionary Art in
response to censorship
of the arts by Fascist
governments in Europe.
Their manifesto, which
demanded a liberated
modern art, was a catalyst
for other like-minded
groups, among them the
Surrealist Art et Liberté
in Egypt.

REVOLUTIONARY SURREALISM

If Dada was the explosion needed to wake art from its aesthetic
slumber, then Surrealism was its shock waves. Originating in Paris
in 1924 with the poet André Breton, the international art
movement was profoundly influenced by Dada and its loathing
of the establishment. Its goal was to liberate man from the constraints
of the super-ego and life from the constraints of the reality principle.
Art institutions were detested for inhibiting artistic freedom, and
Surrealist artists set out to challenge societal conventions by making
work about taboo subjects. These artists believed in returning art to
politics and were sympathetic to Marxist ideology and its language of
internationalism, revolution and freedom.

The Surrealists were prolific manifesto writers, articulating their
demands for utopia in rhetoric so fiery it was as if the cataclysmic
collapse of society were imminent. In 1938 Breton collaborated on
a manifesto with the exiled Bolshevik leader Leon Trotsky and the
Mexican revolutionary muralist Diego Rivera. Their *Manifesto: Towards
a Free Revolutionary Art* argues that 'true art is unable *not* to be
revolutionary, *not* to aspire to a complete and radical reconstruction
of society'. Such militant words found purchase across the world,
as Surrealism inspired artists in Eastern Europe, North Africa, the
Middle East, South America and the Caribbean.

Art et Liberté was a Surrealist group founded in Cairo in 1938,
composed of an Egyptian and international group of writers and
artists, among them the poet Georges Henein, the painters Amy
Nimr, Inji Efflatoun and Ramses Younan and the photographer Lee
Miller. The group were Marxist sympathizers, anti-imperialist and
opposed to the autocratic nature of King Farouk's regime. Wary
of the ruler's sympathies with Italian Fascism, they published the
manifesto *Long Live Degenerate Art* in 1939 in solidarity with the
avant-garde artists being persecuted in Nazi Germany:

> O men of art, men of letters! Let us take up the challenge
> together! We stand absolutely as one with this degenerate art.
> In it resides all the hopes of the future. Let us work for its victory
> over the new Middle Ages that are rising in the heart of Europe.

Art et Liberté continued to agitate for political change in Egypt
during the Second World War, participating in strikes and protests
and publishing criticisms of the regime in the many periodicals they
put out in French and Arabic. But towards the end of the conflict the
group became disillusioned with Breton's steadfast support of Marxist
ideology, particularly in relation to censorship. In a manifesto written

in 1945, they called on Surrealists to defend individual creativity, signing off with the words 'Freedom against terror in all its forms'.

-
Surrealist artists set out to challenge societal conventions by making work about taboo subjects.
-

For all the talk of revolution, the architects of Surrealism were surprisingly averse to direct action. The real objective for Breton was a revolution of the mind. Surrealism was an attempt to restore magical modes of thinking to a technologically rapacious, rational modern world. In 1945, Breton's fellow Surrealist poet Pierre Mabille invited him to Haiti to give a series of lectures. Breton was keen to visit a nation that had, in his view, succeeded in combining the miraculous and the political through the role of Vodou in Haiti winning its independence from France in 1804. He travelled the country studying Vodou practices and became acquainted with the artists associated with the Centre d'Art d'Haiti, among them the painters Hector Hyppolite, Wilson Bigaud and Préfète Duffaut. But Breton got more than he bargained for. His arrival in the Haitian capital Port-au-Prince had coincided with a tumultuous period in the country's politics: within a few weeks President Élie Lescot's government was brought down by protesters demanding reform in the name of Surrealism, partly inspired by the poet's arrival on the island. Breton and Mabille were expelled by the military, who took charge until elections could be held. Breton, however, understood Surrealism's role as only a part of the story: 'Let's not exaggerate' he responded in an interview with Jean Duché in 1946. 'At the end of 1945, the poverty, and consequently the patience, of the Haitian people had reached breaking point.'

LEGITIMATE DEFENCE

Étienne Léro was a young poet from Martinique who hoped to revolutionize the culture of the Caribbean. In 1932, he created the left-wing Surrealist journal *Légitime défense* to protest colonialism and to promote a Black West Indian artistic avant-garde. In its opening manifesto he called for artists to 'rise up here against all those who are not suffocated by this capitalist, Christian, bourgeois world to which, involuntarily, our protesting bodies belong'.

Only one issue of *Légitime défense* was ever published; its open criticism of Martinique's ruling elite meant that the journal was

Légitime défense
1 June, 1932
24.5 x 15.9 cm (9⅝ x 6 in.)
Bibliothèque Kandinsky, Centre Pompidou, Paris

Published in 1932, *Légitime défense* was used to promote a Black West Indian artistic avant-garde that was both Surrealist and Marxist in tone. Only one issue was published before it was banned in Martinique for being anti-imperialist and anti-colonial.

LÉGITIME

DÉFENSE

Textes de :

étienne léro
rené ménil
jules-marcel monnerot
maurice-sabas quitman
simone yoyotte

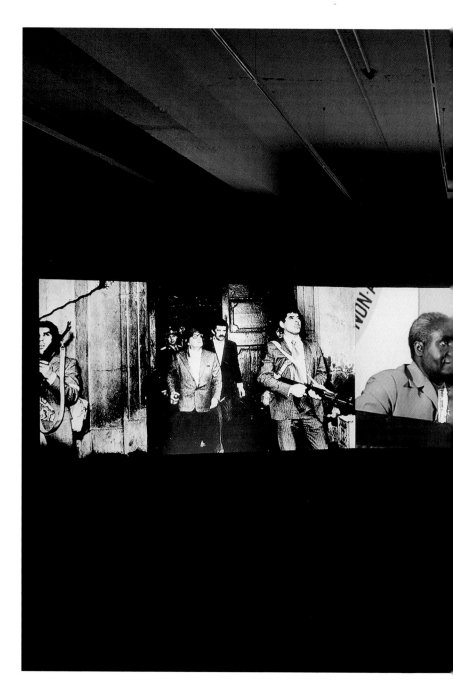

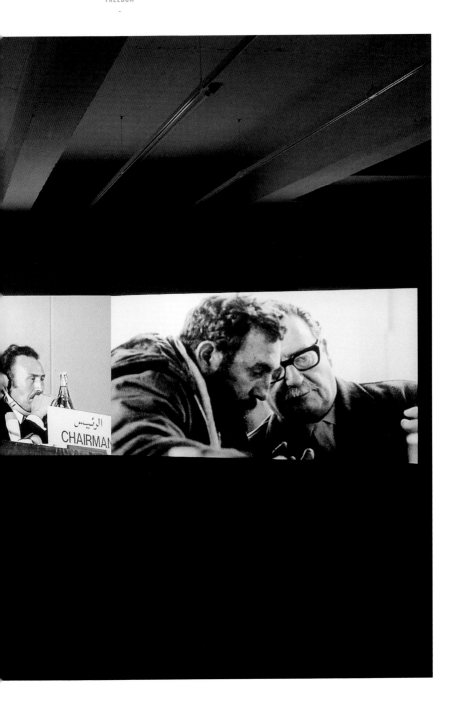

quickly censored. Léro was killed seven years later, fighting in the Second World War. But the publication's furious rhetoric inspired three young African and Caribbean students, Aimé Césaire, Léon-Gontran Damas and Léopold Sédar Senghor, to form a literary and philosophical movement that would go on to reshape the cultural landscape of the African diaspora: Négritude. Césaire was the first to allude to the idea in his impassioned tract 'Négreries: Black Youth and Assimilation', published in the inaugural edition of the Black Student in 1935. The concept drew on Surrealism and sought to reclaim the value of Blackness and African culture and reject the French colonial assimilationist model which, as Césaire later wrote, was predicated on the destruction of sovereignty, religion and artistic heritage.

Césaire would go on to serve as the president of the Regional Council of Martinique between 1983 and 1988, while his Senegalese contemporary Senghor would become the first President of the newly independent Senegal in 1960.

-

Third-Worldism was a non-aligned socialist vision conceived by newly independent states in Africa and Asia as an alternative to Marxism.

-

Meanwhile the philosophy of Négritude was inspiring the post-war Pan-African movement. Pan-Africanism is based in the idea that all people of African descent share a common cultural heritage, and that a collective Black consciousness should be fostered to forge the bonds of solidarity necessary to overcome the deep wounds of slavery and colonialism.

Around the same time, the concept of Third Worldism began to emerge. This was a non-aligned socialist vision conceived during the Cold War by newly independent states in Africa and Asia as an alternative to Soviet bloc alignment. Third Worldism was viewed with deep suspicion by neoconservatives in Europe and the United States, who were fearful of its radical left-wing ideology and anti-colonialism. The movement first inspired the Bandung Conference, a utopian endeavour founded in 1955 in Bandung, Indonesia, when newly independent Asian and African nations gathered in solidarity against Western colonialism and called for a global network of support and self-determination. Later this gave birth to the Non-Aligned Movement (founded 1961, Yugoslavia). The latter Nonalignment is the subject of the contemporary artist Naeem Mohaiemen's three-screen film Two Meetings and a Funeral (2017),

Previous spread:
Naeem Mohaiemen
Two Meetings and a Funeral, 2017
Three-channel digital video installation, 88 minutes. Hessisches Landesmuseum, Kassel, documenta 14. Photo: Michael Nast.

Mohaiemen's film is about the pivotal Non-Aligned Movement meeting of 1973 in Algeria, and its eventual cannibalization by inter-bloc rivalry between Nonalignment and Islamic bloc coalition that started from the Organization of Islamic Cooperation meeting the next year, in Pakistan.

which documents this optimistic era of transnational solidarity before
tactical alliances and religious bloc politics doomed the project.

THE WARRIOR ARTIST

In the 1950s, the brutal suppression by the British of freedom
fighters in Kenya during the Mau Mau Rebellion and the violence
inflicted during the Algerian War on the soldiers of the Algerian
National Liberation Front galvanized Europeans into joining
the anti-colonial liberation struggles. Artists made art, signed
statements and published manifestos on the themes of revolution
and armed resistance. At the World Peace Assembly in Helsinki
in 1955, the French philosopher Jean-Paul Sartre urged his
country's government to give up its colonies in North Africa. In
1961, the psychiatrist and political philosopher Frantz Fanon wrote
The Wretched of the Earth, a highly influential (and prophetic)
text on decolonization. The Moroccan painter Farid Belkahia
created *Tortures* (1961–2) in direct response to the Algerian War

Farid Belkahia
Cuba Si, 1961
Paint on paper, 62 x
44.5 cm (24½ x 17⅝ in.)
Tate, London

This piece is an
expression of support for
and solidarity with Cuba
during the Bay of Pigs
crisis. Belkahia went on
to run the Casablanca
Art School, where
he did away with its
colonial-era curriculum
and encouraged
students to study local
artistic traditions and
techniques.

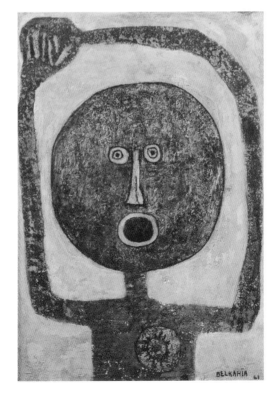

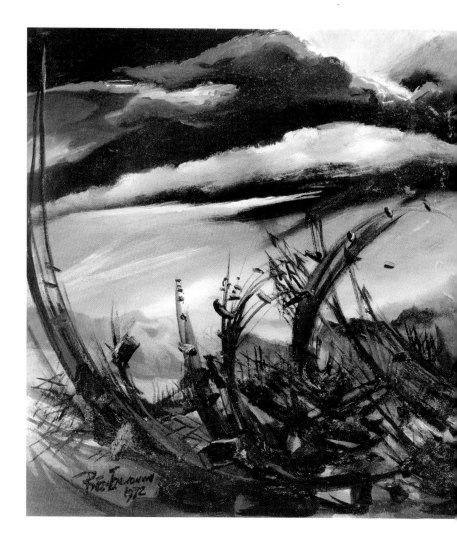

Ben Enwonwu
Storm over Biafra, 1972
Oil on canvas, 78.6 ×
154.3 × 5.2 cm (31 × 60¾
× 2 in.)
National Museum of
African Art, Smithsonian
Institute, Washington DC

In 1967, civil war broke
out in Nigeria. For the
painter Ben Enwonwu,
who had set out to define
modernity in Africa, focus
now shifted to the military
conflict. This landscape
painting suggests both the
physical and psychological
effects of the conflict on
the region.

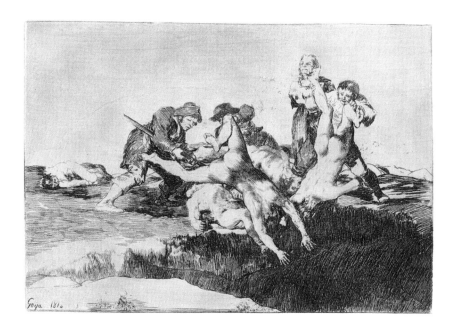

Francisco Goya
Plate 27, 'Charity'
(Caridad), from *The
Disasters of War*, 1810
32 x 22 cm (12⅝ x
8¾ in.)
Metropolitan Museum of
Art, New York

The eighty etchings and
aquatints that make up
The Disasters of War,
Goya's depiction of the
revolt of Zaragoza during
Napoleon's invasion
of Spain in 1808,
remorselessly show the
atrocities committed by
both sides.

and *Cuba Si* (1961) in support of Cuba's communist government during the Bay of Pigs crisis, when the United States backed an attempt by Cuban exiles to topple the regime. In 1970, Belkahia's fellow countryman Tahar Ben Jelloun wrote the rousing manifesto 'On Art and Combat', in which he stated that 'For us, the art of combat is becoming an urgent necessity. In certain countries that are fighting for their liberation, guerrilla art (guerrilla film, guerrilla theatre) has jettisoned many class prejudices that once governed artistic communication.' A year later, the Palestinian abstract artist and art historian Kamal Boullata conceived of the 'warrior artist' in his manifesto 'Art in the Time of Palestinian Revolution', writing: 'The life that surrounds the artist in the third world calls upon him, as a human being, to join the revolution.'

In 1956, at a critical moment in Nigeria's struggle for independence from the British, the artist Ben Enwonwu published a paper in the journal *Présence Africaine* in which he explained that artistic freedom was not possible without political freedom, because colonialism impacted all aspects of everyday life:

> It is a common assumption that art has nothing to do with politics. That this human activity is not a biological necessity and therefore, it is an isolated phenomenon which has no political context nor mission...In fact, every true artist is bound by the nature of the traditional artistic style of his country, to express, even unconsciously, the political aspirations of his time.

Today it is often regarded as axiomatic that art should operate in the political arena, but this has not always been the case. Until the twentieth century, art and politics were seen as distinct from one another. The eighteenth-century Enlightenment philosopher Immanuel Kant considered art to be too elusive, too disorientating to be rigorously conceptualized. He reasoned that an artist's talent was innate and God-given and the act of creation was outside the bounds of rational thought. Politics, on the other hand, was a space of relatively clear, logical argument, far removed from the mystification of art.

There were outriders who undermined this notion: William Blake raged against tyranny and slavery in his cosmically charged visions and satirists wielded their razor-sharp wit against the ruling elite in delightfully vicious fashion. But Kant's concept of the 'inspired genius' was a potent one, later cultivated by philosophers such as Friedrich Nietzsche, who elevated art to a realm of its own when he argued that art was the highest expression of the human spirit.

Such a conceit gave purchase to the idea that artists who made work of a political nature did so by compromising their artistic integrity. This was something Diego Rivera took umbrage at in his 1932 article 'The Revolutionary Spirit in Modern Art', in which he argued that those who favour 'pure' art over political art fail to realize that they are just as political by aligning themselves with an idealized elite over the masses. For the American writer and Civil Rights activist Ralph Ellison, the question was simple. In 1955, in an interview for the *Paris Review*, he said: 'I recognize no dichotomy between art and protest. If social protest is antithetical to art, what then shall we make of Goya, Dickens, and Twain?'

Until the twentieth century, art and politics were seen as distinct from one another.

Francisco Goya's passionate humanitarianism is evident in a series of etchings made from 1810, known as *Los desastres de la guerra* (*The Disasters of War*). The works depict all manner of atrocities, including torture, rape, despoliation and massacre. As in his earlier *Los caprichos* (1797–8), which were a commentary on contemporary social evils, Goya's imagination was ignited by the political situation of the time. The *desastres* series was described by the art historian Robert Hughes as a forceful anti-war manifesto – no one could argue that Goya subordinated himself or his imaginative powers to the cause.

The Spanish Civil War was a brutal conflict that polarized Spain, pitting republicans against monarchists and drawing into the battlefield the international forces of fascism and communism. One of the most shocking atrocities was the carpet bombing of the Basque town of Guernica in 1937 by Nazi German planes supporting General Franco's Nationalists. Two months later at the Paris International Exhibition, Pablo Picasso revealed his painting *Guernica*. The work was not the artist's first protest against Spain's fascists – six months earlier he had drawn a savage comic strip satire titled *The Dream and Lie of Franco* – but *Guernica* captured the public imagination. The work remains an essential point of reference for human beings in fear of their lives. It is often used in protests, on banners and placards, as a symbol of state repression.

The Portuguese-born artist Paula Rego likewise put her art in the service of social change when, in 1998, a referendum to sanction the legalization of abortion in Portugal failed after intensive

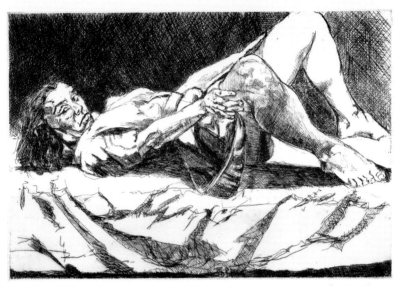

Paula Rego
Untitled II, *The Abortion Series*, 1999
Etching on paper, 20 × 29.5 cm (7⅞ × 11⅝ in.)

Rego objected to the language surrounding abortion, with its focus on shame and humiliation. Her subjects are not victims, but strong, autonomous women undergoing abortions in the full knowledge of what they are doing.

campaigning by the Catholic Church and conservative groups. Enraged by the result, Rego protested the draconian anti-abortion laws through a series of emotive paintings depicting the trauma of backstreet abortions. The artworks reflected the women's courage – they risked prosecution and imprisonment – and stoicism while in appalling pain. The printmaker Paul Coldwell, who worked closely with Rego from the 1980s onwards, described them as tragedies being conducted with the lights on. The pictures were turned into prints and published in newspapers, generating nationwide debate. It took another nine years for abortion to be legalized in Portugal, but Rego's protest paintings are widely regarded as having contributed to the public
shift in opinion.

KEY QUESTION

Is the message or the aesthetic more important in protest art?

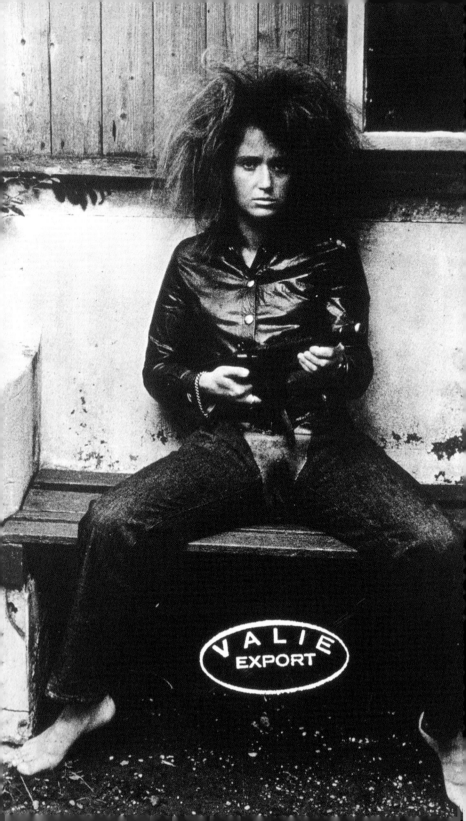

ART AS POLITICAL TOOL

-

If imperialist domination has the vital need to practice cultural oppression, national liberation is necessarily an act of culture

-

Amílcar Cabral

National Liberation and Culture, 1970

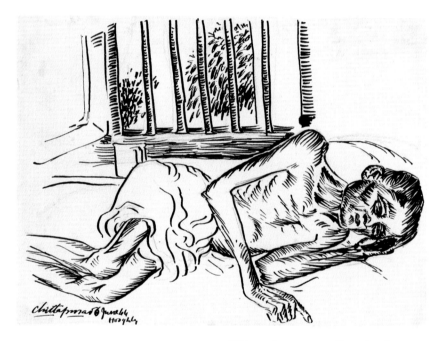

Chittaprosad
Lu, Rajmal, Birbhum, 1944
Linocut on paper, 17.8 x
25.4 cm (7 x 10 in.)

Hungry Bengal was an
investigative report on
the lives of those affected
by mass starvation in
Midnapur in 1943.
Chittaprosad urged
readers to consider
those who had lost their
livelihoods: 'Bodies that
yesterday fought for our
freedom and today are
being literally eaten by
dogs and vultures. Is this
the tribute a nation pays
to its fighters?'

ART AND PROPAGANDA

In his 1962 essay 'Commitment', the German philosopher
Theodor Adorno wrote that it was 'not the office of art to spotlight
alternatives, but to resist by form alone the course of the world,
which permanently puts a pistol to men's heads'. Adorno argued
that art is innately political, but that it should not be used in a
functional manner to propagandize or promote particular policies
or ideologies.

What does an artist do, then, when confronted with a life and
death struggle against the forces of global conflict, imperialism and
corruption? In 1943, the Bengali artist Chittaprosad Bhattacharya
travelled to Midnapur in eastern India with the photographer Sunil
Janah to provide an eyewitness account of the Bengal famine,
one of the most devastating events of the Second World War.
Its depredations had depopulated entire villages, with thousands
of sick and starving people travelling into the cities in desperation.
Each day trucks rattled through Kolkata collecting the dead off
the street.

'I was forced by circumstances to turn my brush into as sharp
a weapon as I could make it,' Bhattacharya was quoted as saying
in Prodyot Ghosh's *Chittaprosad: A Doyen of Art-World* (1995).
The pen-and-ink sketches that he made of famine-stricken
people were printed in the communist newspaper *People's Age*
and subsequently turned into the book *Hungry Bengal*. The images
were hard-hitting. To stop the news of the famine spreading, the
authorities allegedly destroyed all but one of the 5,000 copies
printed.

Some three million people died in the Bengal famine, and
Bhattacharya's experiences profoundly affected his moral and
political outlook. A vocal opponent of British rule since the 1930s,
he began to work consciously to expose corruption in government
and agitate for independence.

Painting as protest is often the only way an artist knows how
to act. The London-based Iraqi artist Dia al-Azzawi has recorded
how, following the mass killing in September 1982 of over
3,000 mostly Muslim men, women and children living in the
Shatila refugee camp and neighbouring Sabra district of Beirut,
Lebanon, by a right-wing Christian militia, he felt compelled
to create *Sabra and Shatila Massacre* (1982–83). The work's
epic scale, distorted bodies and hard-edged geometry make it
a formidable anti-war symbol. The artist refuted the suggestion
that the painting was propaganda: 'It is the documenting of a
tragedy,' he said.

COLLABORATION AND THE COLLECTIVE

Adorno's view that political art is not a legitimate form of expression
was partly born of the philosopher's experiences during the Second
World War and the warped power of the Nazi propaganda machine.
He was wary of communities and collectives, believing that to be
truly free an artist had to remain autonomous. The cultural theorist
Amy Mullin has countered this argument, highlighting that it leaves
many artists out in the cold, particularly those from oppressed or
marginalized communities who draw on each other for support by
working in collectives. Protest art often relies on collaboration to
realize its imaginative potential.

This is certainly true of the radical art activism that emerged with
the women's movement in the 1960s, as female artists united to
claim territory traditionally held by men. Action committees were
set up, museums picketed when women artists were excluded from
group exhibitions and manifestos written to protest the barriers
holding women back from an artistic life. In 1972 the pioneering
Austrian artist VALIE EXPORT urged women to wrest control of
their own image from men in *Women's Art: A Manifesto*: 'Let women
speak so that they can find themselves, this is what I ask for in order
to achieve a self-defined image of ourselves.'

**Protest art often relies on collaboration to realize its imaginative
potential.**

In 1974 in Vienna, protests erupted over the mishandling of an
exhibition of women artists at the Austrian Museum of Folk Life
and Folk Art, which had been planned to open during International

Dia al-Azzawi
*Sabra and Shatila
Massacre*, 1982–83
Ink and wax crayon on
paper mounted on canvas,
300 x 750 cm (118⅛ x
295¼ in.)
Tate, London

**Jean Genet was one of
the first reporters to see
the horrific aftermath
of the Sabra and Shatila
Massacre: 'A photograph
doesn't show the flies nor
the thick white smell of
death,' he wrote in his
essay *Quatre Heures à
Chatila*.**

Women's Year. Forty-six female artists refused to participate when it was discovered that the selection committee had been all-male and subsequent requests for equal representation were rejected. Out of the uproar came the formation in 1977 of the International Action Community of Women Artists (IntAKT) to agitate for improved representation and better working conditions, including state pensions and provision for maternity leave.

In New York, Where We At (WWA) helped set the tone for Black feminist art and organizing. The consciousness-raising collective – founded in 1971 by Kay Brown, Faith Ringgold and Dindga McCannon, among others – sought to affirm and support Black female artists. Their exhibition, held at Acts of Art Gallery in Greenwich Village, focused on the multilayered texture of Black women's lives. The artists believed that if feminism was to succeed, it needed to confront all forms of discrimination, not just sexism – the argument being that your feminism is only as good as the way it treats the most vulnerable in society. This sentiment was later echoed in the 1977 manifesto written by the Black feminist lesbian socialist group the Combahee River Collective: 'If Black women were free it would mean that everyone else would have to be free since our freedom would necessitate the destruction of all the systems of oppression.' WWA worked to eradicate the structural exclusion of Black women from mainstream second-wave feminism at street level, by running nurseries, raising money for Black single mothers and organizing educational workshops.

In Britain in the late 1960s, it fell to the Women's Liberation Movement (WLM) to raise awareness about violence against women, including rape and domestic abuse. Campaigns helped to shape the groundbreaking Domestic Violence and Matrimonial Proceedings Act and the Sexual Offences Act in 1976. WLM established refuges for women escaping domestic violence and support groups for rape victims. But discourse around violence against women could still be contentious, as the artist Margaret Harrison discovered when her collage *Rape* (1978), which featured newspaper cuttings, case reports and drawings, was removed from a show at London's Serpentine Gallery in the same year. Harrison commented that it seemed you could be raped in Britain, but you could not protest against it.

Harrison was a founding member of the Women's Workshop of the Artists Union, which used art as a platform for social change. Perhaps one of the most important artworks to emerge from the group was the sociopolitical installation *Women and Work: A Document on the Division of Labour in Industry 1973–75*, which was

FOTO: PETER HASSMANN

VALIE EXPORT
Aktionshose, Genital panic,
1969
Performance piece

**VALIE EXPORT's
Fluxus-inspired
performances often
feature her own
body in deliberately
provocative ways,
raising questions about
society's perception
of women. This poster
commemorates an action
performed by VALIE
EXPORT in a Munich
cinema in 1968, in which
she walked between the
seats wearing crotchless
trousers in order to
challenge the way women
have been historically
represented in film.**

exhibited at the South London Gallery in 1975. Over two years, Harrison, Kay Hunt and Mary Kelly conducted interviews and collected data to document the working lives of women employed in a factory producing metal boxes in south-east London. Their work revealed a culture of exploitation in which women were confined to low-skilled work, denied promotion and paid considerably less than their male counterparts. When the exhibition opened, the factory owners were appalled and, according to Harrison, tried to ban the workers from seeing the show.

Women and Work was not the first time such a survey had been conducted. Some seventy years earlier, in 1907, the artist and women's rights campaigner Sylvia Pankhurst travelled through Scotland and the north and midlands of England making detailed studies of women working in factories. Her research revealed a very similar situation: women doing low-skilled, repetitive, backbreaking work, which was often damaging to their health, for little pay. Pankhurst's painting series *Women Workers of England* was published in *The London Magazine* in 1908 and was considered a turning point in the Votes for Women campaign, having contributed to Prime Minister Herbert Asquith's understanding of just how many British women constituted the nation's workforce.

More recently, in South Africa, the multiracial photographers' collective Afrapix and the cultural activist collective Medu Art

Margaret Harrison
Rape, 1978
Collage, 223.7 x 244cm
(88⅛ x 96⅛ in.)
Arts Council Collection,
Southbank Centre,
London

**Feminist artist Margaret
Harrison recognized
that violence and
discrimination happening
in the street needed to be
brought into the gallery,
because that was where
the people with power
would see it.**

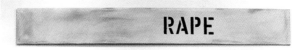

Ensemble (based in exile in Gaborone, Botswana) documented
the ongoing civil resistance and struggle against the apartheid
state during the 1980s. Their work revealed the consequences
of apartheid through photographs, paintings and posters, one of
their primary objectives being to galvanize political action in Black
communities through the arts.

A key protagonist of the Medu Art Ensemble was the artist
Thamsanqa (Thami) Mnyele, who believed that the artist's role in the
nationalist movement against South Africa's white minority rule was
to give dignity to the just thoughts and deeds of the oppressed Black
majority. Artists involved in political protest often do not just want
to critique social and political conditions, but seek to change these
conditions through art. At issue is the question of how to achieve this
without either diminishing artistic quality or aestheticizing political
struggle. Mnyele had seen this problem up close in the 1970s,
when a certain style known as 'township art' became fetishized in
Europe. Pictures of Black South African slums, originally painted
in an outpouring of revolt against poverty and segregation, were
promoted by art galleries as depictions of 'primitive' everyday life.
Painters were encouraged to get on board with this style with the
promise of financial support. It prompted Mnyele to reject the
commercial art world for the life of a socially committed artist.
He joined the Medu Art Ensemble after moving to Botswana in
1979, and in 1982 took part in a festival of 'Culture and Resistance'
to raise international consciousness. In 1985, he was killed by the
South African Defence Force during the Raid on Gaborone, the
centre of the anti-apartheid struggle in exile.

USEFUL ART

The Cuban artist-activist (or artivist) Tania Bruguera has
developed a form of art and philosophy known as Arte Útil
(Useful Art), a way of drawing on artistic thinking to imagine
and implement tactics to change society for the better. Often
her work is directed at supporting and giving a platform to those
without a voice. In 2009, Bruguera first staged *Tatlin's Whisper #6*
(*Havana Version*), which offers audience members '1 minute free of
censorship per speaker', within the framework of the Havana Art
Biennial. When she attempted to perform the piece in Havana's
Revolutionary Square five years later, she was placed under house
arrest by Cuba's communist regime. She was detained again in
2018, for protesting against the government's dystopian Decree
349, which prohibited artists from operating in private and public

Thamsanqa Mnyele
Unity, Democracy and Courage, c. 1983
Screenprint in red and black on white woven paper, 61 × 43 cm (24 × 17 in.)
Art Institute of Chicago, Chicago

Mnyele was a resistance artist and a part of the Medu Art Ensemble, who used art to agitate for decolonization. They described themselves as cultural workers rather than artists, to avoid the 'dilettante' connotations of the word.

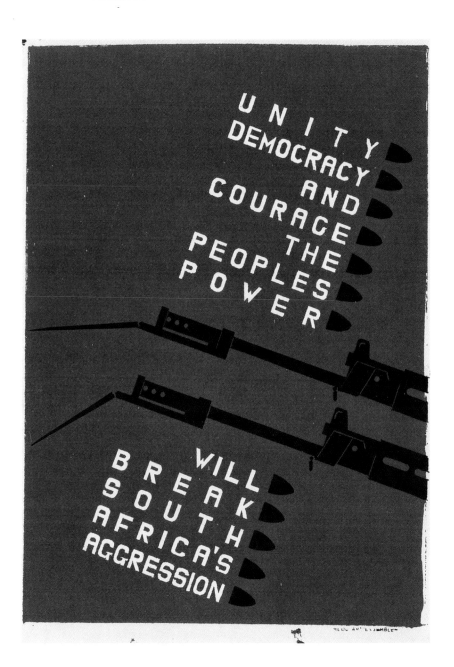

spaces without state approval. 'As an artist...you cannot be living oblivious of the political time you are in,' she explained. In the days following the introduction of the decree, the San Isidro Movement was formed to help bring the Cuban authorities' injustices against artists to global attention. In 2023, the founding member and artist Luis Manuel Otero Alcántara began a five-year sentence, after his arrest in 2021 on the way to an anti-government protest. In an article published in the *Miami Herald* in July 2023, he wrote: 'Today every young Cuban is a political prisoner. A censored artist. An exile inside and outside Cuba.'

The Moscow-based artist-activists Partizaning also operate a form of Arte Útil. They are not interested in contemporary art in the conventional sense. Their urban guerrilla activities seek to give Muscovites greater autonomy in the city. This has taken the form of artist- and citizen-made road crossings and cycle lanes, benches placed around the city, and the provision of 'mailboxes' in several districts for residents to submit suggestions and complaints. Their approach grew out of the breakdown of Russian society after the collapse of the Soviet Union in 1991. In their 2011 manifesto, they write:

Today's activist urban residents do not think of art as a distinct system. They use the language of art as a tool to challenge and change their daily reality.

In a 2014 issue of *e-flux journal*, the cultural theorist Boris Groys argued that art activism can create a space for successful political discourse and action to occur: 'One can aestheticize the world – and at the same time act within it.' He was responding to a charged debate in the German media, begun when the Kunst Werke Institute for Contemporary Art in Berlin invited artist-activists to take it over as part of the city's 2012 biennale. Groys wrote that 'in fact, total aestheticization does not block political action; it enhances it. Total aestheticization means that we see the current status quo as already dead, already abolished'. The resulting Occupy Biennale was a collective endeavour of workshops, printmaking events and symposiums that sought to challenge the traditional structures of the art world. It divided critics, with some describing the DIY style of the biennale as a failure of aesthetics, while others argued that the decision to hold the event inside an art gallery called into question the political relevance of the art institution. How could art have any visible social impact when it was hidden inside a place of established power?

Indignados and 15M at 'Occupy Biennale', 7th Berlin Biennale for Contemporary Art, 27 April–1 July 2012

In 2012 artists and local activists were invited to occupy the Kunst Werke Institute for Contemporary Art, to work and live in the space, share ideas and engage with the public, revealing the hidden processes of social activism.

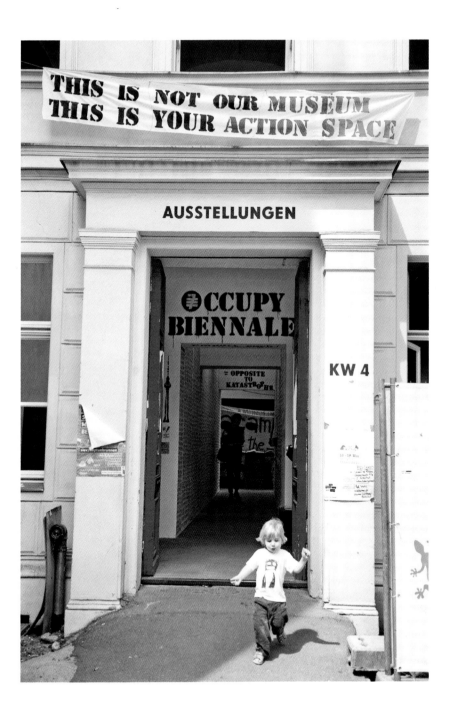

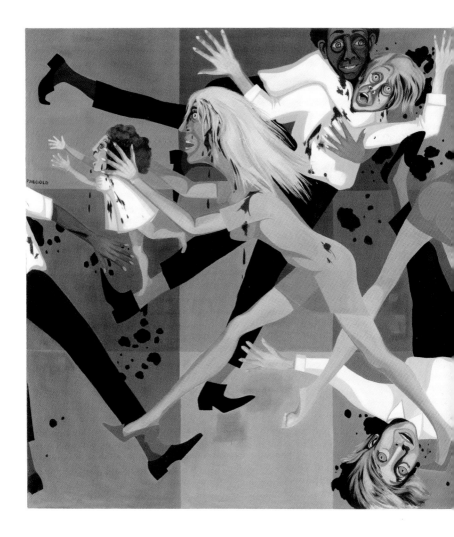

SUPER-REAL

The surrendering of aesthetic considerations to political protest
was of concern to a number of the African American artists
associated with the Civil Rights movement in the United States
in the 1960s. Many had participated in the March on Washington
in 1963 and heard Dr Martin Luther King Jr's 'I Have a Dream'
speech. In the struggle for racial justice, they asked, what was their
role? The responses were numerous, from the sculptor Melvin
Edwards's *Lynch Fragments*, begun in 1963, a series of welded
sculptures reflecting on the sickening history of the lynching of
African Americans, to Romare Bearden's Dadaist photocollages of

Faith Ringgold
*American People Series
#20: Die*, 1967
Oil on canvas, two panels,
182.9 × 365.8 cm (72 ×
144 in.)
Museum of Modern Art,
New York

Ringgold's *American People Series*, begun in 1963, consists of twenty paintings in which she addresses the strained social predicament of race relations between Black and white people in the United States.

Black American street life in the 1960s and 1970s. The Black Arts Movement, begun in 1965, set out to identify a Black aesthetic that could develop beyond Civil Rights protest art to become a form, as the writer Amiri Baraka outlined in 'The Black Aesthetic' in the *Negro Digest* in 1969, 'that uses the Soul Force of Black Culture, its lifestyles, its rhythms, its energy, and directs that form towards the liberation of Black people'.

For Faith Ringgold, the issue was straightforward: 'The idea was to make a statement in my art about the Civil Rights Movement and what was happening to Black people at that time, to make it super-real,' she told the curator Zoe Whitley in 2016. In response

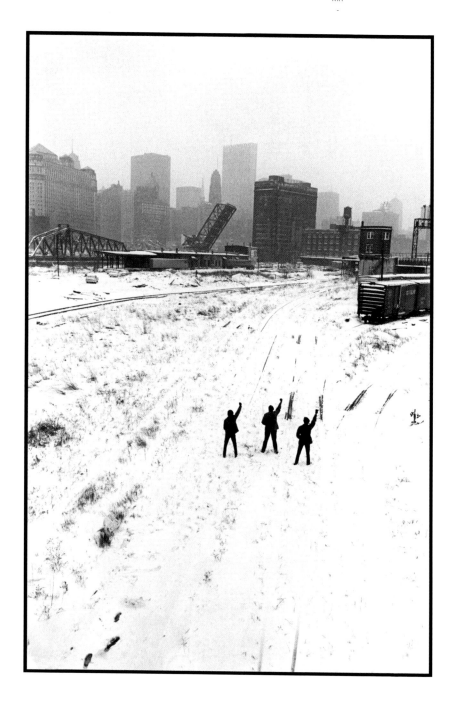

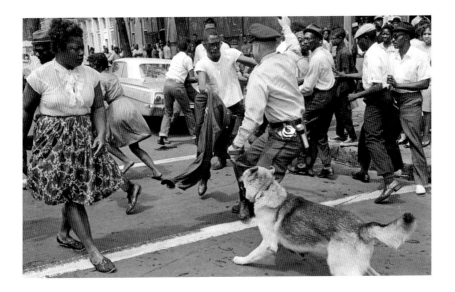

Hiroji Kubota
Black Panthers
protesting. Chicago,
Illinois, US, 1969

Kubota documented the
Civil Rights struggles
in the United States,
beginning with the March
on Washington in 1963.
In Chicago in 1968 he
met members of the
Black Panther Party,
photographing them as
small figures standing
resolute against the
imposing Chicago skyline.

Howardena Pindell
Rope/Fire/Water, 2020
Digital video, 19 minutes

Rope/Fire/Water is a
purposely difficult watch.
The artist combines black
and white footage of racial
violence with the sound
of a ticking metronome.
At times the video goes
black, creating moments
of visual silence when the
reality is too much to bear.

to media sanitization of the uprisings taking place across the US in the
late 1960s, she painted events in blistering colour, reflecting the fear and
shocking pain of racial tensions in everyday life.

The artist-activist Dana C. Chandler Jr's piece *Fred Hampton's
Door 2* (1975) was made in response to the state-sponsored killing
of the Black Panther deputy chairman Fred Hampton. The twenty-
one-year-old organizer was shot dead by police in Chicago in 1969.
Chandler recreated Hampton's front door, riddled with bullet holes,
as a way of disputing the Chicago Police Department's statement
that Black Panther Party members had fired on them. This claim was
subsequently discredited during a federal investigation in which it was
disclosed that Hampton had been asleep at the time of the shooting.

The artist Howardena Pindell began incorporating text into her
abstract works after an art critic wrote that he would like to have
sex under one of her paintings. It was at that point that she realized
she needed to be clearer about what she was saying. That decision
led to the 2021 work *Rope/Fire/Water*, a nineteen-minute digital
video depicting the history of racial violence in the United States of
America that included images of lynchings.

BLACK ART

When, on 20 April 1968, the British Member of Parliament Enoch
Powell made his notorious 'Rivers of Blood' speech to the Conservative
Political Centre in Birmingham, he appealed to currents of racial

hatred and wild surmise about high levels of immigration in Britain
at the time. The speech, in which Powell called for immigrants from
the West Indies and South Asia to be repatriated, followed the
arrival of 24,000 South Asian British citizens fleeing discrimination
from Kenya. Powell's 'evil speech' as *The Times* described it at the
time, exacerbated existing racial tensions; white working-class
fascists shaved their heads and went looking for trouble.

-

**Rasheed Araeen called for a radical Third World Art that
would confront neo-colonialism.**

-

As the Race Relations Act was passed by Parliament, making
it illegal to refuse employment or housing on racial grounds, groups
within the Black and Asian communities were formed to demand
political and cultural autonomy and counteract the racist rhetoric
of Powell and his like. The British Black Arts Movement emerged
out of this volatile landscape. In 1989, the Jamaican-born British
cultural historian Stuart Hall explained in a paper titled 'New
Ethnicities' that the term 'black art' was political. It did not define
an ethnicity or an aesthetic:

> The term 'black' was coined as a way of referencing the common
> experience of racism and marginalization in Britain and came
> to provide the category of a new politics of resistance, amongst
> groups and communities with, in fact, very different histories,
> traditions and ethnic identities.

A key protagonist of the movement was the Pakistan-born
artist Rasheed Araeen, who used his art to condemn the endemic
racism at the heart of the British art establishment. Between 1975
and 1976 he wrote *Preliminary Notes for a BLACK MANIFESTO*, in
which he drew attention to the white supremacy prevalent in the art
world and called for a radical 'Third World' art that would confront
neo-colonialism and challenge the presiding Eurocentric version
of the history of art: 'After exterminating millions of people and
then looting their belongings, the west today has the audacity to
call itself the protector of the artistic and cultural heritage of the
world.' In 1977 Araeen devised the multimedia performance *Paki
Bastard (Portrait of the Artist as a Black Person)*, in which he played a
victimized migrant worker while newspaper clippings reporting racial
violence were projected over him.

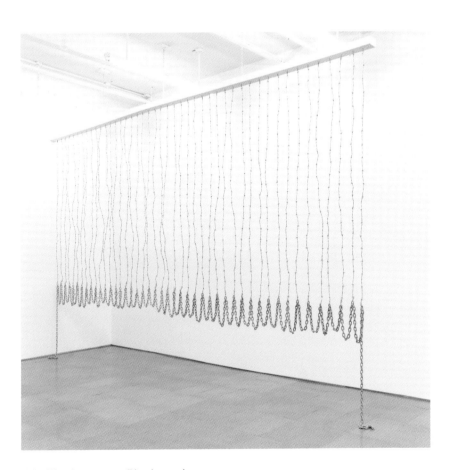

Melvin Edwards
*Curtain (for William and
Peter)*, 1969
Barbed wire and metal
chain
Tate, London

**Edwards created a
delicate abstract
sculpture out of barbed
wire and chains, objects
of Black oppression. As
a way of honouring the
Black artist community
he was a part of, Edwards
dedicated the artwork
to fellow studio artists
William T. Williams and
Peter Bradley.**

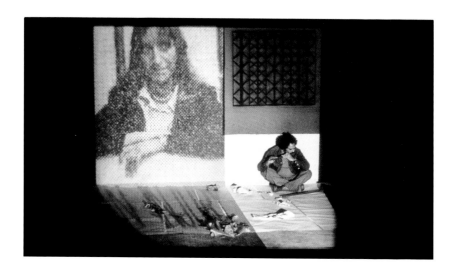

After exterminating millions of people and then looting their belongings, the west today has the audacity to call itself the protector of the artistic and cultural heritage of the world.

Art that confronts neo-colonialism and the legacies of the empire found purchase with many young British artists of Black and Asian descent. In 1980, the city of Bristol experienced the first in a series of major disturbances in Black communities reacting to racist policing, inequality and social deprivation; further riots the following year included Brixton in London, Handsworth in Birmingham and Toxteth in Liverpool. As police lines were drawn, a group of young Black artists who had been raised in the industrial west midlands formed the BLK Art Group. In 1982, in a text titled 'Black Artists for Uhuru', founding member Eddie Chambers appealed for a politically engaged Black art, writing that a Black art student 'should find him/herself drawn towards the nerve points of social and political tension and unrest choosing to respond in this situation by producing work which voices their dissatisfaction with the offending bodies or people, offenders who may at one point in time or another include the police, the state, the educational system, the church, and so on.'

In 1986, the British artist Chila Kumari Burman gave a talk at the Institute of Contemporary Arts in London titled 'There Have Always Been Great Blackwomen Artists'. The lecture was a riposte to the famous 1971 essay by the American art historian Linda Nochlin,

Rasheed Araeen
Paki Bastard, 1977
Performance piece

Made in response to attacks on the South Asian community in east London, Araeen's performance projected images of mounted police, anti-fascist marches, the picketers at the Grunwick strike and newspaper clippings reporting violence against South Asian people. The soundtrack included excerpts from Handel's *Messiah*, which were followed by male voices aggressively shouting racist chants.

titled 'Why Have There Been No Great Female Artists?' Nochlin had explored the lack of educational and social opportunities for women artists, and engaged with the question of who was writing the art history books and so determining who was or was not 'great'. Burman, though, asserted that Nochlin was concerned only with white female artists: 'Blackwomen artists are here, we exist and we exist positively, despite the racial, sexual and class oppressions which we suffer.' The words recall the earlier objections of Where We At to the marginalization of Black women artists in the feminist art movement. Burman chose to fuse the words 'Black' and 'women' together as a way of bestowing a collective identity on previously disenfranchised and misrepresented Black female artists.

KEY QUESTION

How does protest art differ from propaganda?

Sonia Boyce
*Lay Back, Keep Quiet
and Think of What Made
Britain so Great*, 1986
Charcoal, pastel and
watercolour on paper,
4 parts, each 152.4 x
65 cm (60 x 25⅝ in.)
Arts Council Collection,
Southbank Centre, London

This history painting represents areas of the British Empire – Cape Colony, India, Australia and the Caribbean – against a backdrop of William Morris wallpaper. Boyce's early artworks reflected on the experiences of Black women in Britain through paintings that allude to sexual violence, conquest and religion. The title refers to a phrase supposedly said to women on their wedding night: 'Lay back and think of England.'

ART AGAINST WAR

Remember your humanity, and forget the rest.

The Russell-Einstein Manifesto, 1955

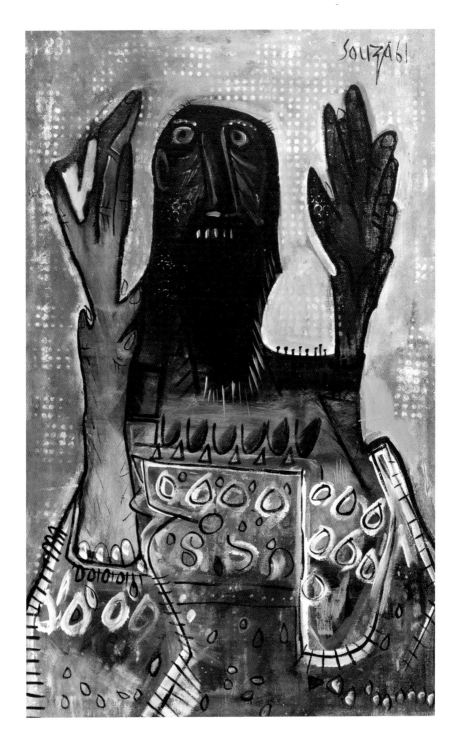

FN Souza
*Mad Prophet in
New York*, 1961
Oil and acrylic on canvas,
115.6 x 73 cm (45½ x
28¾ in.)

In his exhibition
catalogue in 1961, Souza
wrote of this piece:
'The Mad Prophet in
New York. Why mad?
Why New York? Why
the radiation-bitten
hands? The only effective
action to halt the drift
to nuclear war is civil
disobedience – Now. Or
these are the last days of
mankind.'

MAD PROPHETS

A few days after the USA dropped atomic bombs on the Japanese
cities of Hiroshima and Nagasaki in August 1945, the Egyptian
Surrealist Georges Henein wrote: 'These perfected technologies,
these supreme refinements of murder, have done nothing to bolster
the cause of liberty, the cause of humanity.' He accused the USA
and its allies of mass murder and argued that they had come to
resemble their foes.

Over the following decade, as the Cold War between the USA
and its former ally the Soviet Union intensified, artists responded
to the threat of nuclear war with a mixture of moral outrage,
horror and anxiety. Francis Newton Souza articulated his fear
of Armageddon through paintings of mutilated figures. A year
before the Cuban Missile Crisis of 1962, when the USA and USSR
narrowly avoided outright nuclear war, he painted *Mad Prophet in
New York*, depicting a bearded man with hands blackened as if they
have been scorched by radiation. 'The only effective action to halt
the drift to nuclear war is civil disobedience – Now. Or these are
the last days of mankind,' he wrote in the catalogue to his exhibition
at Gallery One in London in 1961.

**Reportage photographers believed that only by facing
darkness could they develop a true realism.**

Although nuclear warfare remained a threat rather than a
reality after 1945, the decision in 1954 by the US military to
test its vastly powerful new hydrogen bomb on Bikini Atoll in
the Pacific Ocean, showering 7,000 square miles in radioactive
fallout, forced Japan to relive the trauma of the atomic
destruction of Hiroshima and Nagasaki. The country erupted
into anti-nuclear 'Anpo' protests against the ongoing presence of
the US military in Japan. Petitions to ban nuclear weapons were
signed by thirty million people – half of the adult population. Out
of these protests emerged a group of young, socially aware artists,
photographers and filmmakers who loosely coalesced under the
title 'Reportage'. They believed that only by facing the darkness
could they develop a true realism. Using their art as a form of
political resistance, they invented a new visual language
to confront the realities of post-war Japan.

Shortly after the Bikini Atoll test, the filmmaker Ishirō Honda
made the gloomily atmospheric film *Gojira* (*Godzilla*) (1954) about

a deep-sea dinosaur, transformed into a giant monster by nuclear testing, which terrorizes downtown Tokyo. The photographers associated with the VIVO (Life) Collective, founded in 1959, promoted a surreal, off-kilter aesthetic, using double exposures and odd camera angles to capture the unsettling times they were living through. The collective took inspiration from Ernst Jünger's militaristic writings on the relationship between war and photography in which he argued that images were an essential part of victory and defeat. In the early 1960s, VIVO co-founder Shōmei Tōmatsu travelled to Nagasaki on assignment to record the relics of atomic devastation, from melted glass bottles to the burn marks on a victim's skin. His contemporary, Ikkō Narahara, became an urban archaeologist, photographing the rapid post-war transformation of the cities and the consequent loss of Japanese traditions and culture.

Nakamura Hiroshi, a Reportage painter and committed anti-nuclear activist who frequently joined the Anpo protests, depicted the raw, often violent confrontations between protesters and the police in his work. *Gunned Down* (1957) was made after an American soldier shot dead a local farmer's wife for trespassing on a US army base. The woman was scavenging bullet casings to sell for scrap

Ikeda Tatsuo
10,000 Count, 1954
Pen, ink, and conté
crayon on paper, 27.8 x
37.3 cm (11 x 14¾ in.)
Museum of
Contemporary Art, Tokyo

**Ikeda drew these mutated
sea creatures in response
to witnessing the dumping
of tonnes of radiated
fish following the United
States's nuclear testing
on Bikini Atoll.**

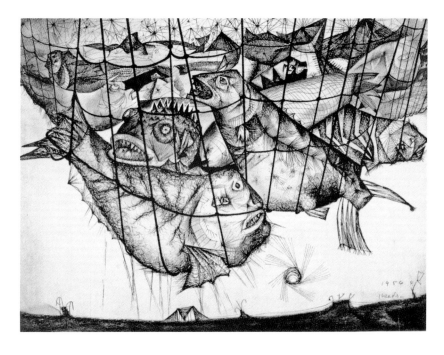

metal. Nakamura used photographs of the tragedy, which had been widely reported in the media, for his painting. Other artists, among them Ikeda Tatsuo, Yamashita Kikuji and Ishii Shigeo, reflected the US military's coercion of ordinary people, be they starving fishermen whose beaches were commandeered as firing ranges, or women who were forced into prostitution.

The artist and agitator Gustav Metzger dedicated much of his life to the campaign for nuclear disarmament. In 1959, he addressed humanity's capacity for self-destruction through a public performance on the South Bank in London. Under a melancholy city sky, beside the River Thames, he sprayed acid onto a suspended nylon sheet, which slowly melted as the chemical dissolved the fabric. Art that destroyed itself, he said in his 'Auto-Destructive Manifesto' that year, was 'a re-enaction of the obsession with destruction, the pummelling to which individuals and masses are subjected'.

Metzger explained that the atomic bomb was the starting point of his work. Under imminent threat of nuclear annihilation, society was 'screaming out for a radical, unprecedented form of art', he told the Architectural Association in 1965. Having watched in horror as the British government stockpiled chemical, biological and nuclear weapons, he joined various protest groups to campaign against their development and testing. A couple of months after demonstrating his auto-destructive art on the South Bank, Metzger was imprisoned along with the eighty-nine-year-old philosopher Bertrand Russell for planning an act of mass civil disobedience in central London as part of the anti-war Committee of 100.

The artists associated with auto-destruction had lived through the Second World War. Metzger had been sent to England from Germany as a Jewish refugee in 1939, while Yoko Ono had witnessed the firebombing of Tokyo by the Allies in 1945. The Destruction In Art Symposium (DIAS) organized by Metzger in London in 1966 brought artists together to voice their opposition to the ongoing threat of nuclear war.

The shadow of nuclear obliteration would also bedevil the next generation. For the artists associated with the Greenham Common Women's Peace Camp in the 1980s, protest strategies centred on imagining the unthinkable – the end of life on earth – and giving it form, such as delivering a child-sized coffin painted with the words Human Race to the gates of the US military base. Craft was another key feature of the protests, the labour and care taken over woven or stitched artworks commanding respect and disarming the militaristic discourse of nuclear defence.

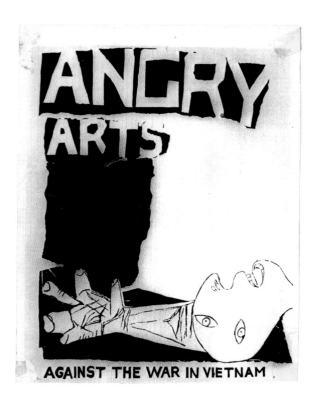

Rudolf Baranik, Artists'
Poster Committee of Art
Workers Coalition
Angry Arts against
the Vietnam War, 1967
Lithograph, 54.3 x
45.1 cm (21⅜ x 17¾ in.)

The poster was inspired
by Picasso's anti-war
protest painting *Guernica*,
which was on show at the
Museum of Modern Art,
New York, during the
AWC's anti-Vietnam War
demonstration.

END YOUR SILENCE

The long, costly conflict that pitted the communist government
of North Vietnam against South Vietnam and the United States
was intensified by the ongoing Cold War between the US and the
Soviet Union. American involvement in Vietnam grew throughout
the 1960s, and by the end of the decade the US was deeply divided
down generational and political lines over the conflict. As reportage
of the bloodshed began to emerge, by tenacious photojournalists such
as Philip Jones Griffiths and Don McCullin – images that the critic
Susan Sontag described in *Don McCullin* (2001) as 'exemplary, gut-
wrenching work' – protests erupted.

In 1966, an anti-Vietnam War tower was built by Mark di Suvero
at the end of the Sunset Strip in Los Angeles. *Artists' Tower of
Protest (Peace Tower)* featured 418 paintings, among them work by
Elaine de Kooning, Robert Motherwell, Ad Reinhardt and Frank
Stella. At New York University, artists emblazoned a *Collage of
Indignation* with satirical anti-war slogans. Many of these artists
went on to sign a statement that appeared in *The New York Times*
in 1967 under the heading END YOUR SILENCE, which called

for citizens to oppose the conflict and the United States's armed intervention in the civil war in the Dominican Republic. The full-page advertisement was part of Angry Art Week, in which artists articulated their anti-war sentiments in performances and artworks across the city.

-

Golub saw little difference between the oppressor and the oppressed.

-

The painter Leon Golub and the feminist artist Nancy Spero were two of the signatories of the 'End Your Silence' statement.

Nancy Spero
L.O.V.E. T.O. H.A.N.O.I.,
1967
Gouache and ink on
paper, 91.4 x 61 cm
(36 x 24 in.)

Spero said that the inspiration for her paintings was the image of a woman running from her house, which had been set on fire by helicopters. She imagined the victims of war in Vietnam and what they would think of these war machines.

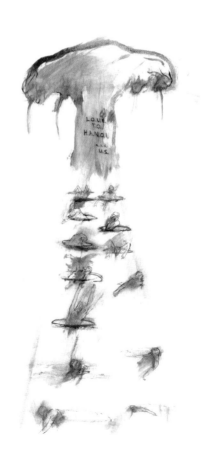

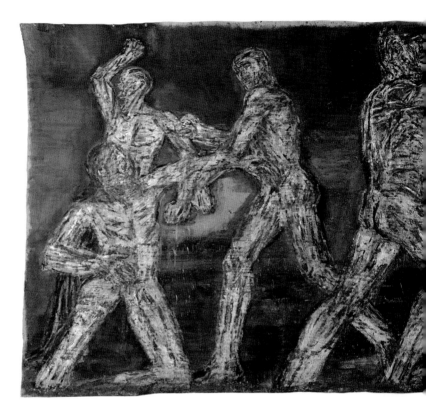

Leon Golub
Gigantomachy II, 1966
Acrylic on linen, 303.5 ×
758.2 cm (10 × 25 ft)

The left-wing figurative
painter focused on the
destruction done by
men, and here depicts his
generalized characters
locked in an endless
struggle of violence.

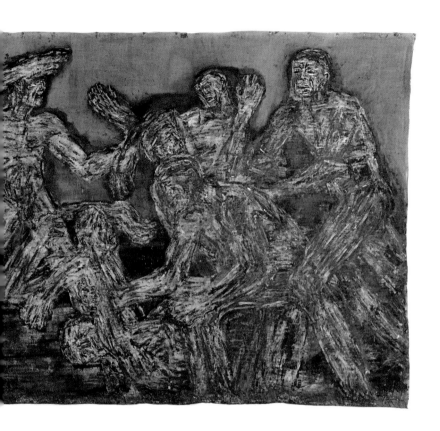

PROTEST
ART

Golub roared his protest into life in the form of a giant frieze, bloody and fraught with violence. The *Gigantomachy* series (1965–68) was scorched earth writ large, a writhing mass of bodies locked in a gladiatorial battle on an unprimed canvas. Golub saw little difference between the oppressor and the oppressed, situating both in an abyss that rendered them impotent. His aim was to take his audience to places they didn't want to go. In 1974 Golub described the combatants in the painting to the interviewer Studs Terkel as being like 'robots in a man's guise because all they do is struggle'. Where Golub focused on the physicality of violence, Spero's protest looked to the perspective of its victims. Her *War Series* paintings, made between 1966 and 1970, are full of outrage: made in quick bursts, they have a jarring and frenetic energy. 'Maybe the strongest work I've done is because it was done with indignation,' she told the non-profit organization Art21 in 2007. 'The *War Series* paintings are certainly a protest.'

Sensitive to the urgency of the times, Faith Ringgold incorporated her experiences of the Civil Rights movement into her anti-war art, explaining that she wanted to be part of the struggle. Her work raised issues of masculinity and white supremacy, and the inherent racism in the conflict (many of the soldiers drafted into the US military were from poor Black families). Ringgold's *Flag for the Moon: Die N**** (1967) reflected the disjunction between the money spent to put an American flag on the moon, and the deprivation experienced by many Americans, particularly the Black community. Ringgold continued to incorporate the US flag – which she saw as a culturally contentious symbol – into her work. In 1970 she and fellow artists Jean Toche and Jon Hendricks were charged with desecrating the flag during 'The People's Flag Show', a protest exhibition at the Judson Memorial Church in New York City at which an American flag was burned. The exhibition had been organized in response to the sentencing of Marc Morrel for using flags in his anti-war sculptures. The choreographer Yvonne Rainer had also created a piece for the exhibition, in which nude performers danced with the Stars and Stripes around their necks. The poster advertising the event read 'How dare you tell artists what they can do? That's the beginning of some really bad funk – bad, bad, bad.'

SHARPENED TEETH

In an interview given to the *New Internationalist* in 1989, the Mozambican painter Malangatana Ngwenya said: 'Like all the young children who grew up with me in the 1940s I saw many things –

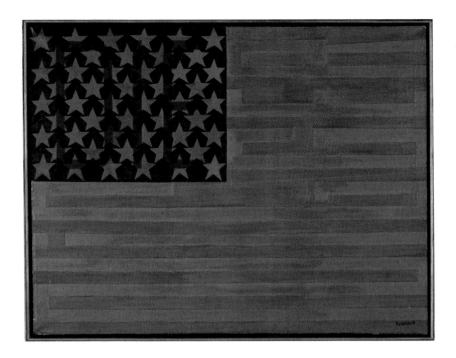

Faith Ringgold
*Black Light Series #10:
Flag for the Moon: Die
N****, 1967
Oil on canvas, 91.4 ×
127 cm (36 × 50 in.)

Ringgold has said that
she grew up thinking
of the American flag as
a symbol of freedom,
but that those freedoms
were being eroded in the
1960s. The artist has
painted the words 'DIE'
behind the stars and the
second word of the title
within the stripes, the
racist hate speech hiding
in plain sight.

many things which made my life political from the start. I saw my
parents forced to work on the railways without food. I saw my aunts
and my uncles being punished by the colonial police.... All this was
preparation for a political life.'

Born under Portuguese colonial rule in Mozambique in 1936, in
1961 he met Eduardo Mondlane, who became leader of FRELIMO
(Frente de Libertação de Moçambique). Mondlane persuaded
Ngwenya to join the anti-colonial struggle and use his art for
political purposes; in 1964 Ngwenya was arrested and jailed by the
PIDE (Portuguese secret police). He created paintings that are
psychologically charged and shockingly violent, their overlapping
figures clawing at each other with bloodied mouths and razor-sharp
nails. Having experienced the brief optimism that came with his
country's independence in 1975, he then saw Mozambique descend
into a horrifying civil war. 'The mouth of society has sharpened teeth,
the only way to destroy a monster is to pull out his teeth,' he said.

The artist Abu Bakarr Mansaray, working under the name
Prof. Abu, has articulated his anxieties about his native Sierra
Leone with a warped ingenuity, devising blueprints and prototypes
for fictional destructive military machines with titles like *Terrific
Poisonous and Hostile* (2011) and *Sinister Project* (2006).

Malangatana Ngwenya,
Untitled, 1968
Oil paint on headboard,
111.5 × 192.5 × 4.9 cm
(44 × 75⅞ × 2 in.)
Tate, London

Ngwenya uses bold colours, hard outlines and cartoonish characters to tell stories about violence and oppression and give fear a face.

Like Ngwenya, Mansaray deploys cartoonish imagery to tell stories of oppression. Absurd and beautiful, his bizarre constructions cast an imaginative, sometimes humorous eye on conflict and economic collapse while also reflecting the unimaginable terror of the war machine for the citizens of Sierra Leone during the civil war of the 1990s and early 2000s.

The Greek-born British artist Mikhail Karikis has taken inspiration from science fiction, inveighing against the degradation of our environment and imagining dystopian futures. *No Ordinary Protest* (2018–19) is based on the poet Ted Hughes's 1993 children's book *The Iron Woman*, in which a female superhero gives young people the power of noise. Over the course of a year, Karikis worked with the pupils of a London primary school to articulate their anger at the ongoing destruction of the natural world.

KEY QUESTION

How can protest art be used to challenge war and oppression?

Abu Bakarr Mansaray
Terrific Poisonous and Hostile, 2006
Ink, colour pencil and pencil on paper, 100 × 150 cm (39⅜ × 59⅛ in.)

The trauma of Sierra Leone's civil war between 1991 and 2002 can be seen in these futuristic drawings, which combine science fiction with weapons of mass destruction.

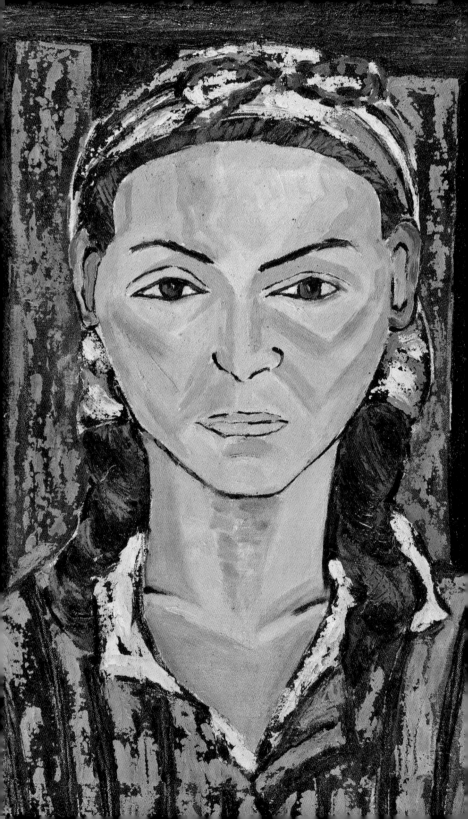

PROTESTING BODIES

The best and most extraordinary artists will be
those who every hour snatch the tatters of their
bodies out of the frenzied cataract of life, who,
with bleeding hands and hearts, hold fast to the
intelligence of their time.

-

Richard Huelsenbeck,
First German Dada Manifesto, 1918

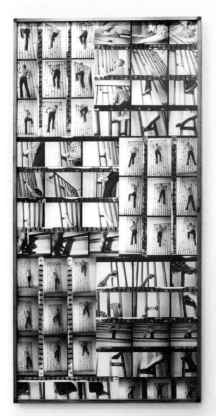

Gina Pane
*Climbing without
Anaesthesia*, 1971
Black and white
photographs on wooden
panel, 323 x 320 x 23 cm
(127¼ x 126 x 9⅛ in.)
Centre Pompidou, Paris

Gina Pane pushed
her body to its limits
both physically and
psychologically. She
considered her pain as a
protest and her body as
the sacrifice.

PERFORMING PAIN

In 1972, the French artist Gina Pane stunned onlookers by cutting her face and body with a razor blade. The performance, titled *Le lait chaud* (*The Hot Milk*), subverted the idea of women as passive victims by taking control of the violent act itself. Pane undertook a number of these ritualistic actions based on wounding, performed in front of an audience, in the 1970s. The most famous of these is *Escalade non-anesthésiée* (*Climbing without Anaesthesia*), in which she clambered barefoot up and down a ladder embedded with metal spikes until her feet were so wounded she could not continue. Pane said her work was an intervention to awaken an 'anaesthetized society'.

It is perhaps no surprise that the body took on a central role in feminist avant-garde art from the 1960s and 1970s. Women distilled their anger about their restricted roles into demands for equal pay, equal opportunities and the right to have an abortion. There were protests about male violence and the way women's bodies were represented in the media. Activists united through magazines, newsletters and symposiums. Protest against male-dominated culture was vocalized in the screaming sound poems of the Hungarian artist Katalin Ladik. The Serbian artist Marina Abramović revealed the inherent sadist lurking within us in *Rhythm O* (1974), a performance in which she surrendered her body to the hands of the audience, leading to a six-hour ordeal in which she was stripped naked, cut with a knife and threatened at gunpoint.

Men also pushed their bodies to extremes in the avant-garde art of this period. In Japan, the choreographer Tatsumi Hijikata developed an intensely powerful performance art called Ankoku Butoh (Dance of Darkness), which sought to subvert conventional ideas of dance and find a mode through which to express ugliness, terror and anguish. It incorporated elements of Surrealism in the way that its movements seemed disconnected from the physical form. In 1968 the writer Tatsuhiko Shibusawa described Ankoku Butoh in *Outlook* as 'possessing a universality that seeks to encompass the whole of creation'.

In 1959, Hijikata and Yoshito Ohno staged the first Ankoku Butoh performance, *Kinjiki* (*Forbidden Colours*), based on Yukio Mishima's icy novel of erotic manipulation. A right-wing author and actor, Mishima was attracted to the intensity of Ankoku Butoh. He believed that his life could be divided into four 'Rivers': Writing, Theatre, Body and Action. In 1970, after an attempted coup that aimed to overthrow Japan's 1947 democratic constitution, Mishima staged his own ritual suicide (*seppuku*) at a military base in central Tokyo as a final dramatic act of protest.

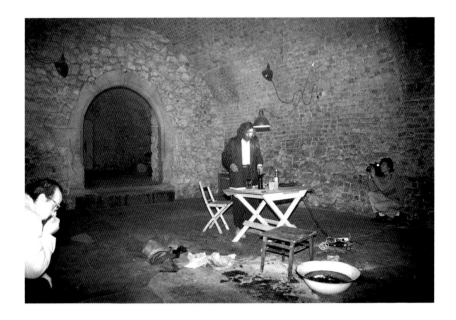

In Austria, the Aktionists Günter Brus, Otto Mühl, Hermann Nitsch and Rudolf Schwarzkogler expressed their outrage at the hypocrisy of the country's conservative post-war society in performances so visceral that members of the audience were said to have fainted. Schwarzkogler, the most extreme of the group, portrayed ideas of damaged masculinity by photographing himself seemingly mutilated or wrapped in bandages; in the documentary film *Being and Doing* (1984), the British performance artist Stuart Brisley recalled the horror of being in the audience of such an Aktionist event. In 1980, he attended a happening by the Polish artist Zbigniew Warpechowski, and described the moment 'When you saw him hovering with his hand above that nail, you suddenly got this terrible glimpse – you knew exactly what he was going to do. He pushed the nail through his hand... I had to get up and get out of that room very fast, I suddenly thought I'd got a heart attack.'

Zbigniew Warpechowski
Political Performance,
12 March 1990

Warpechowski tortured his body as a way of protesting the communist administration in Poland and the dysfunction of Cold War psychology and politics.

LOCKED UP

Repressive states have long tried to inhibit artists. A regime might torture, imprison, exile or even kill an artist in an attempt to silence them, but those working in such circumstances have inevitably found creative modes of surviving and subverting the restrictions that are meant to control them.

In 1956 the Surrealist painter Inji Efflatoun was imprisoned in Egypt after General Nasser became president. An active feminist and Marxist, in her memoir Efflatoun recorded how painting in prison became her way of resisting the nationalist regime. Her early works depicted the prison and the suffering of its inmates, 'piled on top of one another in filthy holding cells where they would suffer horrific treatment'. But after a while the prison and her fellow detainees began to sicken her: 'The whole place disgusted me. I began to paint what nature there was behind bars.' Next to the prison was a small tributary of the Nile where sailing boats passed by, and she said, 'Seeing the wind in the sails stirred many sorrows in me and sparked an uncontrollable desire for freedom.' Efflatoun painted the boats as a form of resistance against her own immobility.

Like Efflatoun, the Sudanese painter Ibrahim El-Salahi saw his art as an act of defiance. In 1975, he was arrested and wrongfully accused of anti-government activities following a Libyan-backed insurrection in Sudan. He was beaten and incarcerated in Khartoum's Kober Prison for six months. He later recalled how,

Inji Efflatoun
Portrait of a Prisoner, 1959
Oil on canvas, 44 x
30 cm (17⅜ x 11⅝ in.)
Mathaf, Museum of
Modern Art, Doha

Efflatoun was imprisoned by President Nasser's regime for her communist activities between 1959 and 1963. Her paintings prior to her incarceration had been critical of the bloody nationalist struggles against British control of the Suez Canal. In prison she painted the portraits of her fellow inmates and bribed a guard to smuggle them out to her sister.

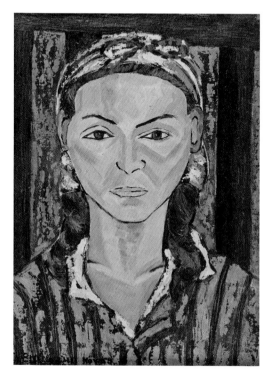

Ibrahim El-Salahi
Prison Notebook, 1975
Ink on paper, 28.7 × 17 cm
(11¼ × 6¾ in.)
Museum of Modern Art,
New York

**In prison, the Sudanese
artist conceived of a
nine-part painting titled
The Inevitable, which he
described as a message
for people to rise up
against oppression. In
2010 he started work on
The Arab Spring Notebook
in response to the
protests happening across
the Arab world.**

on arriving there, the other inmates had told him, 'Thank God
you are free.' It was only later that he understood their meaning
– being in jail meant he was free from political corruption. This
metaphysical concept of freedom left a powerful impression on
El-Salahi and became a source of inspiration after he was released
from Kober and placed under house arrest. His *Prison Notebook*
(1976) is a series of drawings, poems and prose that explores
the creative possibility of incarceration through spirits, mythical
creatures and memories. The book begins with a drawing titled
Each Window Has Two Faces:

The internal face: who you were and what you were doing and
your intentions and hopes and aspirations. And the outer face:
It comes from beyond. You have no control over it, but it has
control over you.

The German-born Uruguayan artist Luis Camnitzer conveys
a vivid sense of state-sanctioned violence in his *Uruguayan Torture
Series* (1983–84), in which a series of photo-etchings depicting
objects such as a broken light bulb, or close-ups of his body, are
accompanied with short descriptive sentences that suggest physical
violence: 'The weight drove his pulse into the wall'; 'His knee
recorded each step'. Camnitzer has interrogated the history of state
abuses and repression in Latin America throughout his career, in
work such as *Leftovers* (1970), a wall of bloodied, bandaged boxes,
each numbered and labelled 'Leftover'.

**Efflatoun saw how painting in prison could be
a way of resisting the regime.**

In 2017, the Kurdish artist and journalist Zehra Doğan was
imprisoned in Turkey on charges of spreading propaganda in favour
of a terrorist organization. Her crime was the dissemination of a
small picture she had painted of the devastated town of Nusaybin, in
south-east Turkey, following clashes between the Turkish military and
Kurdish separatist fighters. Doğan endured almost 600 days in jail;
much of her time was spent in acts of creative defiance, making art out
of the materials to hand. She painted on cardboard and clothing using
coffee grounds, crushed herbs and spices. After her release she told the
Guardian in 2020, 'In prison, I had two choices: either to accept it,
and complain, or try to continue my art as a means of resistance.'

The invasion of Ukraine by Russia in 2022 heightened the already immense pressure on Russians to conform to President Vladimir Putin's narrative, and consequently the danger for artists in the country. The artist and LGBTQ+ activist Yulia Tsvetkova has been detained repeatedly under pornography and 'gay propaganda' charges since 2019. In 2021, she went on hunger strike in protest at her arrest for managing a feminist website and producing body positive drawings.

In 2022, the musician and artist Sasha Skochilenko was arrested and imprisoned for spreading false information about the Russian military; she had applied stickers to supermarket goods that protested the bombing of an art school and a theatre, where many unarmed civilians were sheltering, in the Ukrainian city of Mariupol. The same tactic has been used by the Feminist Anti-War Resistance, a Russian feminist group founded in 2022 to oppose the invasion of Ukraine.

THE CITIZEN

Works that critically examine the trauma of interrogation and detention have been used by artists to protest against human rights atrocities. The Citizen (1982–83) is one of three paintings made by Richard Hamilton responding to the events of 'the Troubles', the violent conflict in Northern Ireland between Irish nationalists and British unionists. It depicts an emaciated republican prisoner on hunger strike staging a dirty protest. Hamilton painted it after he was struck by the appearance of an IRA detainee on television. 'It was a strange image of human dignity in the midst of self-created squalor, and it was endowed with a mythic power most often associated with art,' Hamilton wrote in the catalogue for the 1983 exhibition 'A Cellular Maze', where The Citizen was first shown. 'Even in an environment of total deprivation, humanity will find a means of protest.'

In 2004, during the Iraq War, photographs of the tortures and abuses inflicted by the US military on prisoners at Abu Ghraib were leaked to the media. The pictures revealed the cruelty and hypocrisy of the US-led 'coalition of the willing' and their so-called 'war on terror' after the 11 September attacks on New York and the Pentagon. The soldiers were following routines established for the treatment of Islamist terrorist suspects held at Guantanamo Bay in Cuba, in prisons in Afghanistan and at other sites in occupied Iraq. One of the many humiliations revealed in the reports was prisoners being forced to clean their cells with toothbrushes for hours at a time. The following year, the Cuban American artist Coco Fusco staged a number of works in response

Richard Hamilton
The Citizen, 1982-83
Oil paint on two canvases,
217 × 206 × 5 cm (85½ ×
81⅛ × 2 in.)
Tate, London

This painting depicts Hugh Rooney, one of twenty-eight Republican detainees held at the Maze prison in Antrim. The British government had deprived the prisoners of their 'special category status' and in protest the detainees had refused to wear prison uniforms, wash or shave, and had smeared shit on their cell walls.

Coco Fusco
Bare Life Study #1, 2005
Performance piece

The term 'bare life'
is described by the
philosopher Giorgio
Agamben as being the
condition of living under
a state without full
rights of citizenship: the
condition of prisoners
and of some migrants.
Fusco documented a
military performance in
front of the US consulate
in São Paulo in Brazil
in protest at the way
prisoners were being
treated in Guantanamo
Bay detention camp.

to the atrocities. In *Bare Life Study #1*, a group of women dressed in the orange boiler suits worn by Guantanamo detainees cleaned the street with toothbrushes outside the US consulate in São Paulo, Brazil, while Fusco, dressed in combat fatigues, stood over them. The work also highlighted the role of women in the military; barred from front-line combat, women are often posted to these prisons. Fusco warns of the dangers of situations that give one group arbitrary powers over another.

In the nerve-wracked days after 9/11, the Bangladeshi American artist Hasan Elahi was detained at a US airport. On being released he was monitored for months thereafter. Elahi, an artist who is concerned with the nature of interpretation, turned his imposed surveillance against itself by bombarding the authorities with daily updates about his life and activities. In an Orwellian *volte-face* he sent snapshots of the food he ate, text message updates and emails of his whereabouts. This absurdist act wrestled back control of his own surveillance and also, perhaps, foretold a dystopian future that has since come to pass, in which people voluntarily publish the minutiae of their daily lives, which can be tracked and traced.

Hasan Elahi
Tracking Transience, 2003

In the aftermath of 9/11, President George W. Bush's government granted extra powers to the police and curtailed civil rights in the name of protecting freedom. Muslim minorities suddenly found themselves in the glare of security services. In 2002, Elahi was detained at Detroit airport and later polygraphed nine times. He was kept under close surveillance by the FBI; in response, he began to document his life minute-by-minute, posting photographs, records and logs online for all to see.

WALLS AND BARRIERS

In 1961, at the height of the Cold War, a wall was built through the heart of Berlin to separate the communist German Democratic Republic's half of the city from that of the democratic Federal Republic of Germany. The barrier became a symbol of repression and the frontier of a divided world. On the East German side, few people saw the wall, held back as they were by barbed wire, breezeblocks, barricades and armed soldiers. On the West German side, the wall became a magnet for cryptic slogans and bright, eye-popping graffiti. By the 1980s it was a tourist attraction, and famous artists such as Keith Haring were allowed to paint sections; Haring covered his in colourful dancing figures.

In November 1986, five masked men painted a white line over this dayglo landscape. The line started in Mariannenplatz in the Kreuzberg district in West Berlin and travelled across the city, past the notorious Checkpoint Charlie, until it stopped abruptly south of the Brandenburg Gate, where the men were ambushed by border guards from the East. The line was an artistic protest by five former East Germans who had left for the West and discovered that the wall was being used as a giant playful canvas, sprayed in the garish colours of a new consumer society. No one seemed to want to be reminded of what was on the other side. They re-drew the boundary in white paint to remind the people of West Germany that the wall was there.

Since the early 2000s, the massive barrier in the occupied West Bank has separated large parts of Palestinian territory from Israel. Winding through the landscape for some 500 kilometres, the wall of vast concrete slabs, metal gates and razor wire has become a focus for international street artists and Palestinians protesting against their incarceration. On his website, the street artist Banksy describes it as having become 'the ultimate activity holiday destination for graffiti writers'. Banksy's contributions include a stencil of children being hoisted skywards by balloons and a *trompe l'oeil* image of a desert island.

AFTER SILENCE

Remembrance plays an important role in protest art and in ongoing struggles against oppression, especially when it speaks for those who have no voice. In Brazil in the 1960s, the Portuguese artist Artur Barrio staged a series of visceral street happenings in Rio de Janeiro, in which he placed bloody bundles of rotten meat, bones and excrement in public spaces. *Situação T/T1* was made in protest at the

Artur Barrio
Situação T/T 1, 1970
Cables, meat, blood,
bones. Record photos,
colour slides, 30 x 45 cm
(11⅞ x 17¾ in.)

**Barrio advocated anti-art
as a survival strategy,
performing political
actions in the street
rather than in a gallery
to avoid censorship and
possible imprisonment.**

Overleaf: Doris Salcedo
Act of Mourning, Plaza de
Bolívar, Bogotá, 2016
Approx. 25,000 candles

**Doris Salcedo creates
monumental installations
that echo the magnitude
of the political violence
and corruption in
Colombian society.
Plaza de Bolívar has a
long history of use for
rallies and protests, and
Salcedo's 'mourning
action' draws on this
existing significance.**

tactic pursued by Brazil's brutal military junta of dumping the bodies of tortured and murdered civilians on the streets.

These artistic interventions were designed to reflect the trauma of existing under a military regime. 'In my work, things are not indicated but rather lived,' Barrio explained in the catalogue for his 2006 exhibition 'Actions after Actions'. His bloody bundles goaded the police and shocked the public who came upon them casually on their way to work, forcing them to confront the atrocities happening around them.

The Colombian artist Doris Salcedo has been making art about the civil war between government forces, far-right paramilitaries and communist guerrillas that has afflicted her country for more than fifty years. She describes her installations as 'mourning actions' for those who have disappeared: 'My work is a demonstration of the dead, a demonstration of the missing,' she told *AWARE* magazine in 2017. The year before, she covered Bogotá's central Plaza de Bolívar with a vast white shroud bearing the names of the war's many victims in protest at the government's attempts at a cover-up. 'It wasn't enough to simply displace the victims, to assassinate them – there was also a will to erase them,' she said.

KEY QUESTION

Is progressiveness a defining feature of protest art?

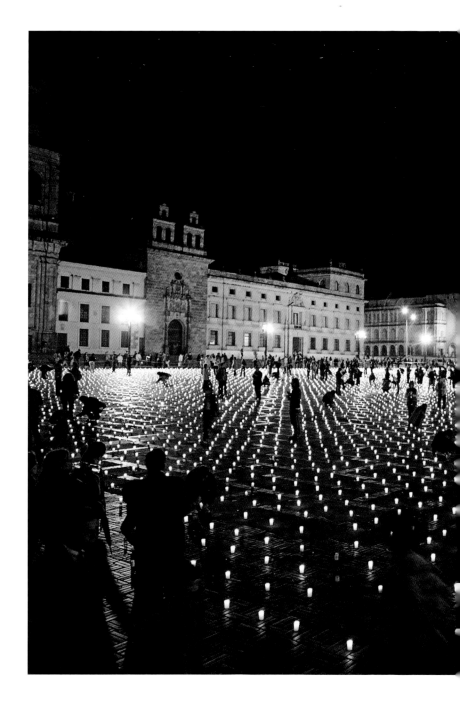

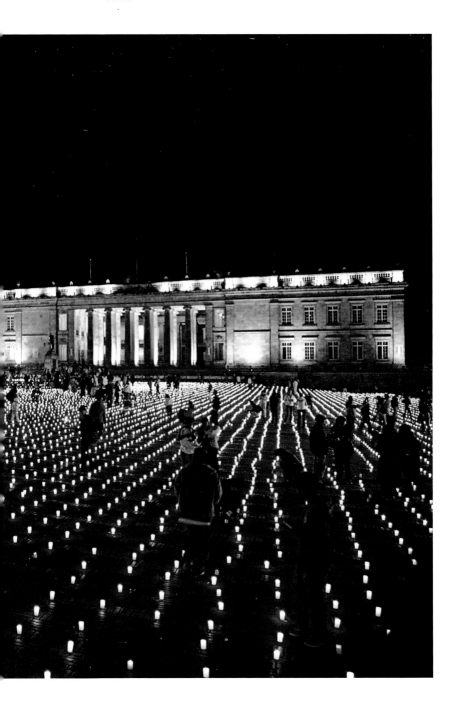

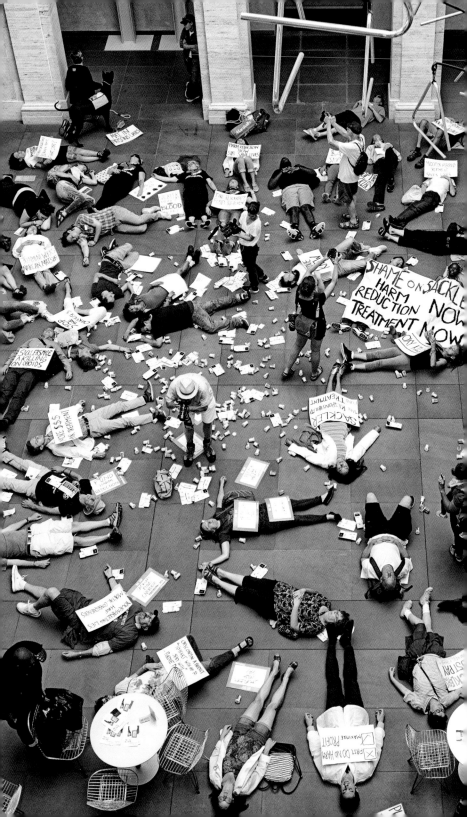

ART AND INSTITUTIONS

–

Museums, graveyards!
They're the same thing, really, because
of their grim profusion of corpses that
no one remembers.

–

F. T. Marinetti, The Futurist Manifesto, 1909

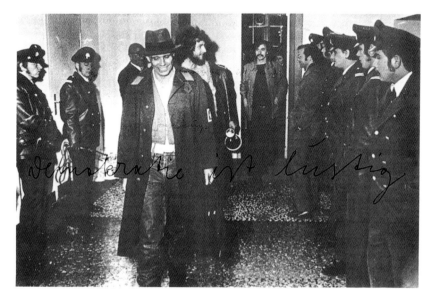

Joseph Beuys
Democracy is Funny
(*Demokratie ist lustig*),
1973
Screenprint with ink
additions, 75 x 114.5 cm
(29½ x 45 in.)
Museum of Modern Art,
New York

The moral force of
Beuys's art arose out of
a need to confront his
country's unspeakable
past. Believing art
to be a catalyst for
political change, he
encouraged his students
at the Kunstakademie
Düsseldorf to challenge
power and participate in
political activity. In 1972,
he was dismissed after he
staged a sit-in.

CHANGE THEM OR DESTROY THEM

The year 1968 was one of political turmoil, and many artists responded to its call for revolution with collective action. The participatory art that had developed throughout the 1960s became the perfect vehicle for the anti-authoritarian struggles that paralysed many cities across the world, as mass protests against the Vietnam War coalesced with the desire to bring about social and political change.

In Paris, artists with hair-trigger revolutionary reflexes were emboldened by the philosopher Jean-Paul Sartre's call for a liberation of everyday life. They fought for a political rebirth through Situationist happenings. Their existential actions were accompanied by the agitprop imagery of the Atelier Populaire, which produced free posters in a stark, monumental style to get their messages across to the public. In London, meanwhile, students occupied Hornsey College of Art in protest at the lack of funding for the arts and the plan to subsume art schools into the new polytechnic system, denying them their autonomy. Groups such as the Vietnam Solidarity Campaign encouraged students to stage sit-ins across the country in opposition to the Vietnam War, and an arts festival was held in Trafalgar Square under the name 'Thang Loi' – meaning 'Victory' in Vietnamese.

In Japan the provocative Tokyo-based art cooperative Bikyōtō (Council of Artists for a United Front) became a thorn in the side of the authorities when they staged a ten-month-long protest at Tama Art University in 1969. The artist Hori Kōsai distributed flyers under the heading 'Why Are We "Artists"?', in which he argued for creative freedom: 'Only by pointing towards a change in kind will we achieve liberation of the individual and our own creative expression.' The artist and his fellow student revolutionaries were documented in the grainy black-and-white images of Shōmei Tōmatsu, one of the founders of a new photography magazine, *Provoke*, which sought to express the political turmoil of the time through a new pictorial language that its proponents called 'are-bure-boke': grainy, blurry and out-of-focus. *Provoke* only lasted three issues – about as long as the student protest movement – but its radical vision for protest photography continues to be an influence today.

It was during this time that artists began to investigate the relationship between the subject, the object and the place where art was exhibited. This became known as 'institutional critique' and it spurred artists into questioning the role played by museums and galleries in society and their connections to political power. In New York in 1969, artists released cockroaches at a trustees' dinner at the Metropolitan Museum of Art in protest at its exhibition 'Harlem

on My Mind: Cultural Capital of Black America, 1900–69'.
The exhibition had been criticized for not consulting the local Black
community it claimed to represent. In 1970, the US-based Art
Workers' Coalition (AWC) ordered an 'art strike' against racism,
sexism, repression and war in front of Picasso's protest painting
Guernica (1937). One of the concerns of the collective was the
connection between art institutions and corporate power. At the
Museum of Modern Art, where some of the members of the board
of trustees were financially benefiting from the war in Vietnam,
the artist-activist Jean Toche later said:

> [Museums] have become essentially a capitalist tool – a tool for
> entertainment and a tool to augment the financial wealth of the
> art world. Change them or destroy them.

Adrian Piper withdrew an artwork from the New York Cultural
Centre in protest at the US government's invasion of Cambodia
and the killings of student anti-war protesters. *Hypothesis Situation
#3* (1968–69) considered the value of a television as an object in
its own right against its use as a medium for entertainment and
information. Piper replaced it with a statement warning that the
current political crisis was changing the context of her work.

-

**David Medalla embodied the ideal of the artist as the
conscience of society.**

-

Some artists, among them the inexhaustibly imaginative David
Medalla, came to embody the ideal of the artist as the conscience
of society. In 1969, at the opening of the Cultural Centre of the
Philippines with guests of honour Nancy and Ronald Reagan (then
Governor of California), Medalla unfurled banners painted with the
slogans DOWN WITH THE PHILISTINES! and WE WANT A
HOME NOT A FACIST TOMB! Medalla had become increasingly
concerned with the right-wing nationalism of President Ferdinand
Marcos, and his regime's 'nerve-wracking fragmentation' of the
Philippines, as Medalla described it to the art critic Guy Brett in
Exploding Galaxies (1995). One of Marcos's strategies was to present
himself and his wife Imelda as incarnations of the Filipino creation
myth of Malakas and Maganda (the first man and woman in Filipino
folklore). This image was fostered by state-sponsored cultural events
held at the newly built arts centre. Medalla went on to co-found

Artists for Democracy with Guy Brett, Cecilia Vicuña, John Dugger and Rasheed Araeen. The organization was originally intended to support the campaign for democracy in Chile after General Pinochet's brutal military coup, but it soon became an artistic and political network backing liberation movements across the world.

In West Germany in 1972, against a backdrop of countercultural avant-garde art and experimental left-wing politics, Joseph Beuys and a group of students occupied the offices of the Düsseldorf Academy of Art. The protest was the culmination of a decade-long dispute between the artist and the academy, which had begun in 1961 when Beuys was appointed its professor of monumental sculpture. On taking up the position Beuys controversially abolished his course's curriculum and entrance requirements, arguing that the hierarchical structures of the institution needed to be broken down. Everyone had the capacity to be an artist, he said. The occupation lasted until the police were called and he was escorted off the premises. Beuys's stand-off came at the end of the revolutionary dream. The collective hope of the 1960s was soon followed by exhausted withdrawal, as behind the scenes right-wing agent provocateurs undermined the radical student movements.

ART ATTACK

In October 2022, two climate activists from Just Stop Oil threw a can of Campbell's soup over Van Gogh's *Sunflowers* (1888) at the National Gallery in London, in protest at the greater value and protection afforded to art than the natural world. The stunt received an aggressive backlash in the media. In response, Just Stop Oil explained that they had been holding rallies in Parliament Square every Saturday, picketing oil company headquarters and targeting fossil fuel infrastructure by blockading oil terminals for months with little interest from the media. Nothing gets column inches quicker than the (supposed) vandalism of a priceless work of art.

Discussions of structural racism and calls for reform do not draw public attention like the toppling of a statue does.

The toppling of the bronze statue of the seventeenth-century slave trader Edward Colston, brought down in Bristol by Black Lives Matter protesters in 2020, came after years of attempts to have the statue removed by democratic

means. Statues cannot teach history, however discussions
of structural racism and calls for reform do not draw public
attention like the toppling of a statue does – it is difficult to
imaging the subsequent, wide-ranging public debates about
Britain's colonial past that took place in the media without
that striking act of protest.

This is something that the early twentieth-century Suffragettes
understood. In total some fifteen paintings were vandalized by
Suffragettes, exploits that led the Vorticist artist Wyndham Lewis
to write in the first edition of *Blast* magazine in 1914, 'We admire
your energy. You and artists are the only things...left in England
with a little life left in them.' He did, however, go on to say they
could have the vote on the condition that they stopped vandalizing
art, just in case they accidentally destroyed something good.
That paintings came in for attack is perhaps not as surprising as
it might at first seem, given that a significant number of those
associated with the campaign for women's suffrage were artists.
It was the very experience of training as an artist, a field in which
women faced discrimination in relation to scholarships, travel
grants and access to life drawing classes, that radicalized many
of them into joining the movement.

DISPOSSESSION

Calls for museums to return stolen cultural artefacts have become
increasingly heated in the 2010s and 2020s. In 2018, a report
commissioned by President Emmanuel Macron of France
recommended the full restitution of looted African artworks
currently in French collections. In the UK, protests for restitution
have been held at the British Museum, where a large number of the
Greek Parthenon Marbles and important Benin bronzes, among
many other artefacts whose ownership is contested, are held.

In 2013, the French-Algerian artist Kader Attia created the
multimedia work *Dispossession*, which scrutinized the Vatican's
collection of African artefacts and the legacy of Catholic missionary
work and cultural imperialism in Africa. Attia has continued to
explore the history of colonialism and resistance, and in 2020 he
re-engaged with the subjects of restitution and colonial collections
in *The Object's Interlacing*. It juxtaposes video interviews of
historians, anthropologists, activists and politicians with a display
of specially copied African artefacts. The Congolese activist and
creator of the Front Multiculturel Anti Spoliation (Multicultural
Front Against Pillaging) Mwazulu Diyabanza has taken a more direct

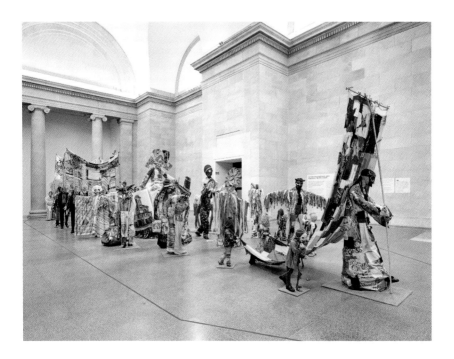

Hew Locke
The Procession, 2022
Mixed media including
cardboard, fabric,
gluegun, PVA, plastic,
fibreglass, wood, metal,
resin, paint and 150 life-
sized figures. Installation
at Tate Britain: 5 x 6 x
85 m (16 ft 4 ⅞ in. x 19 ft
8 ¼ in. x 278 ft)
Tate, London

Locke's work has made
the semi-invisible visible
by refiguring the often-
overlooked statues of slave
owners and colonizers in
Britain's public squares
in bright, carnivalesque
garlands and fabrics. *The
Procession*, made for Tate
Britain, is a triumphant
sweep across history
revealing the legacies of
Empire.

approach, livestreaming himself attempting to remove cultural
objects from museums in order to draw attention to the sheer
quantity of plundered artefacts held in Europe's museums
and collections.

-
**All museums follow some form of political agenda, whether
they are privately or publicly funded.**
-

In the twenty-first century, museums have increasingly become
the focus of campaigns to examine the provenance of objects in
their collections and address institutional and structural racism.
Spurred on by the Black Lives Matter movement, many European
and American museums have questioned the extent to which they
have directly or indirectly profited from the transatlantic slave
trade, as well as the provenance of objects in their collections. These
projects have attracted fierce criticism from right-wing politicians
and commentators, who frame them as a plot to 'rewrite history'.
Central to these debates is the question of how museums position
themselves both ethically and politically.

119

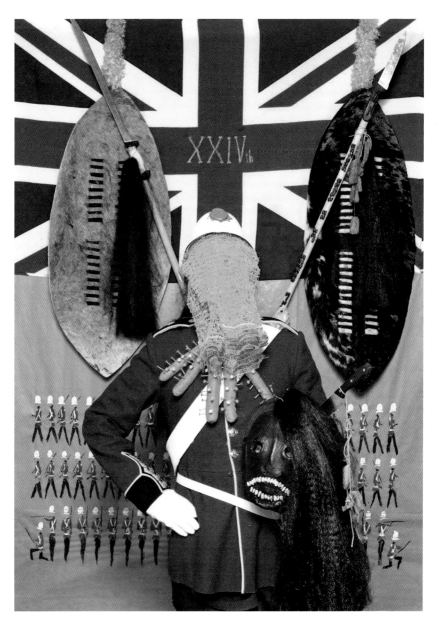

Andrew Gilbert
*Fix Bayonets and Die like
British Soldiers Die*, 2007

Gilbert challenges
the Euro-American
obsession with so-called
'primitive' art by making
fetish objects relating
to European culture,
to, in his words, 'show

how primitive European
society is'. This sculpture
is inspired by the
1964 film *Zulu*, which
romanticized the violence
of the British Empire.

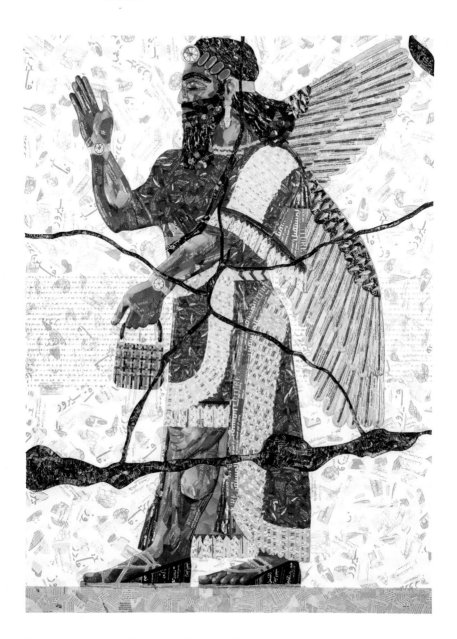

Michael Rakowitz
The invisible enemy should not exist (Room H, Northwest Palace of Nimrud) H-17, 2020

Middle Eastern food packaging and newspaper with glue on panel, 230 x 170 cm (90½ x 67 in.)

Rakowitz has reconstructed historically looted and recently destroyed artworks from the ancient palace of Nimrud in Assyria (present-day Iraq) in

cardboard relief, using Middle Eastern food packaging and Arabic newspaper cuttings.

Kader Attia
Dispossession, 2013
Exhibition view 'After
Year Zero', Haus der
Kulturen der Welt, Berlin,
2013. Double slide, single
slide and video projection
(colour, sound), video
6 minutes 43 seconds,
slides 13 minutes

The French-Algerian
artist's work considers
the role of colonialism
in contemporary society
through the themes
of injury and repair.
In *Dispossession* Attia
addresses the theft by
missionaries of religious
artefacts belonging
to indigenous African
communities.

Artists can be compromised by the place in which they choose to exhibit. All museums or cultural institutions follow some form of political agenda, whether they are privately or publicly funded. Governments can appoint political allies as their trustees, and many institutions are dependent on charitable foundations. Large donations by private individuals or organizations can be used to interfere in decision-making and to influence the programming of exhibitions.

The American artist Andrea Fraser exposed the connections between museums and the political elite in a study she undertook following the revelation that Steven Mnuchin, a trustee of the Museum of Contemporary Art in Los Angeles, was the national finance chairman of Donald Trump's campaign to become president. The resulting book, *2016 in Museums, Money and Politics* (2018) makes for sobering reading, a detailed analysis of museum governance listing the links between cultural philanthropy and the political donations of more than 5,000 board members. It suggested that the United States was run by the super-rich, and that museums had become 'pay-to-play country clubs for millionaires'.

Cultural patronage also brings with it the question of reputation laundering. A good way for a billionaire with a financially dubious past to protect their legacy is to become a philanthropist. The Sackler family, which has several museum wings named after members, had an almost mythic status in the art world for their philanthropic largesse. Few questioned the ethics of how the Sacklers had gained their wealth until 2019, after a series of protests by the American artist Nan Goldin and the activist group that she had founded, PAIN (Prescription Addiction Intervention Now). To draw attention to the Sacklers' role in the opioid epidemic, Goldin led a series of 'die-ins' at prominent international art institutions that had accepted large charitable donations from the family. In 2019, PAIN showered the lobby of the Guggenheim in New York with fake prescriptions that quoted an email exchange between Robert Kaiko, the inventor of the synthetic opioid OxyContin for the Sackler-owned Purdue Pharma, and the company's president, Richard Sackler. In response to Kaiko's concerns about the highly addictive qualities of the new drug Richard Sackler had replied: 'How substantially would it improve our sales?' When Goldin was invited to stage a retrospective at the National Portrait Gallery in London, she made it a condition of her acceptance that the gallery refuse a donation of a million pounds from the family. It worked, and the National Portrait Gallery became the first major museum to refuse Sackler money.

The purpose of non-violent direct action is to create a certain amount of low-level disruption in order to attract attention to a

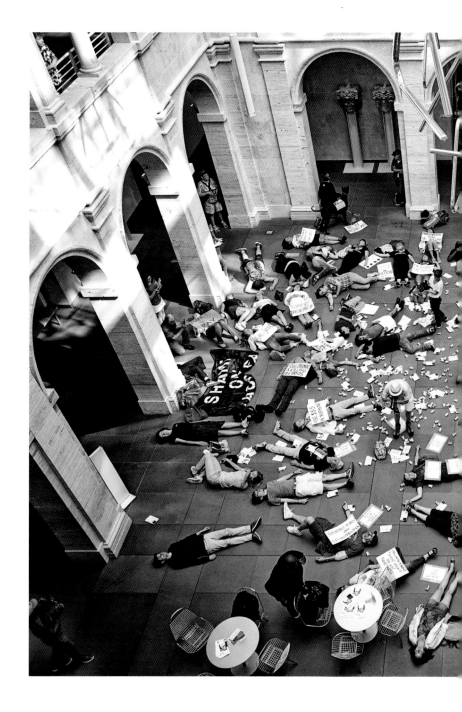

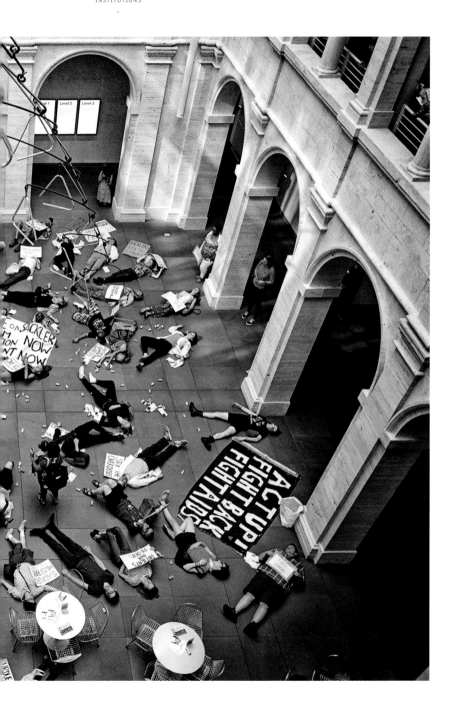

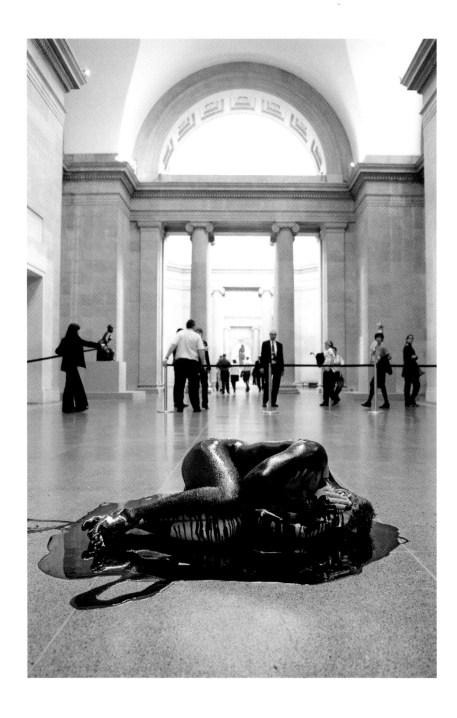

Previous spread: PAIN protesting the Arthur M. Sackler Gallery, Harvard Art Museum, July 2018

Nan Goldin's work has depicted her friends in New York's queer scene, the unfolding AIDS crisis and her drug addiction and subsequent recovery. In 2014 she was prescribed OxyContin after an operation, which led to an opioid addiction; in recovery, she founded the protest group PAIN.

Liberate Tate Amy Scaife's protest performance *Human Cost* at Tate Britain's Duveen Gallery, 2011

Liberate Tate called on museums, specifically Tate, to break their sponsorship ties with oil companies over their responsibility for climate change. In 2017 the oil giant BP stopped sponsoring the museum.

cause, and ideally to avert far greater disruption if demands for change are not met. Until 2016, when the oil firm BP ended its long-standing sponsorship of Tate, the climate-activist art collective Liberate Tate took to occupying the museum's galleries in protest at the institution's acceptance of fossil fuel sponsorship. The group deployed a variety of creatively disruptive tactics to garner public support. For *Human Cost* (2011), a naked performer lay in a foetal position on the floor of Tate's Duveen Gallery covered in an oily substance. Staged on the first anniversary of the BP Deepwater Horizon disaster in the Gulf of Mexico, it lasted for eighty-seven minutes, one minute for every day of the oil spill.

KEY QUESTION
When major art institutions start collecting and exhibiting protest art, what difference does that make to how it should be perceived?

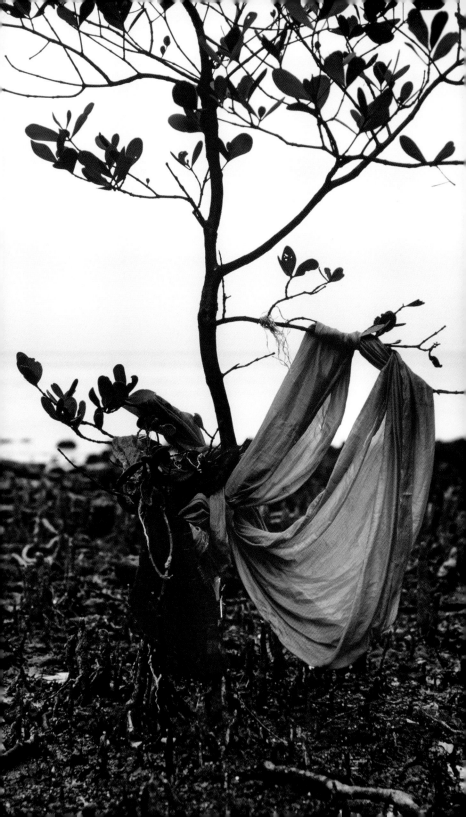

ART AND THE MEDIA

-

Artists not only have the right to dissent,
but the duty to do so.

-

Tania Bruguera, Manifesto on Artists' Rights, 2012

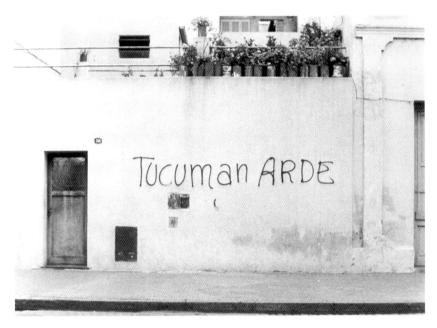

Graciela Carnevale
Vanguard Artists Group,
Tucumán Arde, 1968

After the Argentine
revolution of 1966, artists
began to explore how
they could use art to
combat the repression
and censorship of the
new military dictatorship.
The VAG were left-wing
and actively involved in
society, and sought to
disseminate 'counter-
information' to combat
state propaganda.

THE MEDIUM IS THE MESSAGE

In 1964, the Canadian philosopher Marshall McLuhan published his theory that meaning varies depending on the mode of communication used to convey it, a concept neatly summed up as 'the medium is the message'. This gave rise to actions by artists using the press as both the medium and the subject of artworks. For the left-wing Vanguard Artists Group, living in Argentina under the repressive rule of the country's military dictatorship, McLuhan's theory engendered an ingenious way of evading censorship by the authorities.

In 1968, they staged a fictional arts festival and invited the media to attend. When the press arrived, they discovered not a festival, but documentary evidence of starving factory and farm workers in the Tucumán province of north-west Argentina, where the forced closure of the sugar mills had led to widespread devastation. The event was duly publicized by the media and set a precedent for further subversive antics by South American artists that used the media to document and disseminate acts of protest. One of the most striking was the action carried out in 1979 by the radical Brazilian collective 3Nós3 to highlight the brutal violence of General João Figueiredo's regime. They covered the heads of public statues in plastic bags and bound their arms as if they were being tortured, and then alerted the media, who reported their intervention widely.

At the same time, diverse media strategies were being adopted by feminist artists. In Paris there emerged a vibrant and militant period of radical femininity spearheaded by filmmakers such as Carole Roussopoulos, who used the medium of video to protest

Carole Roussopoulos
Film still from *Le FHAR* (Front homosexuel d'action révolutionnaire), 1971

In the 1970s, France saw a particularly creative period of radical feminism in art. Roussopoulos, who recorded Valerie Solanas's notorious SCUM (Society for Cutting Up Men) manifesto and documented fellow artist Gina Pane's searing performances, created incisive films about protest and liberation movements, capturing the debates within the organizations and the strategies they deployed to fight prejudice.

at discrimination against women in the workplace and domestic violence. She documented protests and marches, including the Lyon sex workers' strike and occupation of Saint-Nizier Church in 1975, and the radical actions of the FHAR (Front homosexuel d'action révolutionnaire).

Diverse media strategies have been adopted by artists to highlight oppression.

In 1977, the American artists Suzanne Lacy and Leslie Labowitz used the media to publicize their rage and grief at the lack of action by the police towards capturing the serial killers terrorizing women in Los Angeles. In a ritualistic performance, nine women dressed in black and one in red stood in mourning outside City Hall in protest at violence against women and the portrayal of women as victims of assault in television, film and magazines. After each woman spoke, the entire group chanted, 'In memory of our sisters we fight back!' *In Mourning and in Rage* received international media coverage in part because of its performative qualities, but also because it was designed specifically for television. The artists even designed their banner so that its proportions fitted TV screens.

Suzanne Lacy and Leslie Labowitz
In Mourning and in Rage, Los Angeles City Hall, 1977
Performance piece

The Hillside Stranglers terrorized Los Angeles between 1977 and 1978, murdering ten women and girls. Lacy and Labowitz's performance was a protest against the sensationalist way the case was reported in the media and the lack of wider discussion about violence against women (400 women had reported being raped during that same period).

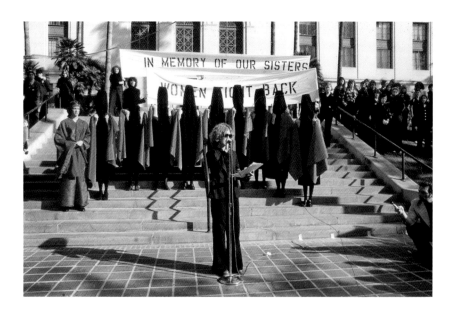

Protest art may seem to speak only to and for people the artist is already engaged with. The difficulty lies in those that don't share their convictions. Can art convince them? Or does it simply alienate? In 1979 the US artist Jenny Holzer set out to see if she could change people's minds through art by flyposting the streets of New York City with a series of provocative statements designed to ignite the silent fury in her readers' hearts. Holzer's *Inflammatory Essays* (1979–83) were vehement proclamations about the existing state of affairs in the United States, written in capital letters on coloured paper, and keeping to a 100-word limit; enough, she said, to 'be mad; they [the messages] could be really, really angry.' She followed these agitprop actions up with slogans on billboards and LED screens that parodied the soundbite rhetoric of the then-US President Ronald Reagan.

In 2018, after seventeen students and staff were murdered at Marjory Stoneman Douglas High School in Florida in a mass killing, Holzer publicized her condemnation of American gun legislation with *It Is Guns*, in which she fitted trucks with LED screens flashing phrases such as TOO LATE / KILL RATE; AMERICAN STUDENTS SHOT. During the COVID-19 pandemic, Holzer sent these trucks back out onto the streets with headline-grabbing slogans attacking the government's mishandling of the emergency. The artist's work provokes, disturbs and disorientates in much the same way as the words of former Presidents Trump and Reagan. She fights the promulgators of hate speech with their own methods.

ART'S DARK TWIN

Advertising has sometimes been described as art's 'dark twin', thanks to its slick, persuasive imagery. In the 1960s, Pop Art subverted advertising's visual tricks to critique consumer society. However, some other artists saw their potential for more radical protest. One of the most high-profile multimedia art events was undertaken by Yoko Ono and her partner, John Lennon, in 1969. The pair began a two-week 'bed-in for peace' that was followed by a huge billboard campaign in twelve cities around the world featuring the slogan 'WAR IS OVER! If you want it. Happy Christmas from John & Yoko.' The bed-in took inspiration from Dada, together with Gandhi's non-violent protests and contemporary student sit-ins.

Ono had been one of the founding members of the conceptual movement Fluxus in 1960, where Happenings and Dada met experimental music in performances with the likes of La Monte Young and John Cage. These occasions provided the springboard for

Overleaf: Jenny Holzer
It is Guns, 2018;
LED truck, New York,
2018

Holzer is always looking for new ways to get her message across. In 2018, in response to the Parkland school shooting, she mounted LED billboards onto trucks emblazoned with the stark message 'IT IS GUNS' and sent them out to cities across the United States.

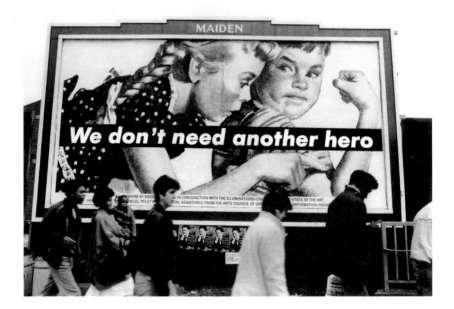

Ono's subsequent career as a conceptual artist and musician. For Ono, a survivor of the firebombing of Tokyo in March 1945 that flattened the city into a twisted, blackened wreck, the Vietnam War had brought up the trauma of the past. She and Lennon confronted it with disarming Dadaist satire.

The American conceptual artist Barbara Kruger began her career as a graphic designer at magazines, and it was there that she learned how to use the shiny visuals of consumer society to transform complex and challenging issues into easily digestible messages. In her art, Kruger manipulates the aesthetics and tactics of advertising to produce immediately arresting images that make a broad political point. Since the 1970s, she has been a campaigner for women's rights, particularly for legal abortion in the United States. *Your Body is a Battleground* (1989) was created for the 1989 Women's March on Washington in support of reproductive freedom; it was given new life in 2022 as part of the protests against the Supreme Court's overruling of the landmark 1973 judgment Roe v. Wade, which had enshrined the right to legal abortion in the US constitution.

Brandalism is an artists' collective in revolt against the corporate control of culture and public space. Since the group emerged in East London in 2012, they have illegally hijacked billboards and replaced their consumer adverts with witty artworks that call out politicians and corporate greenwashing. *LETS RUIN EVERYTHING* (2023), a

Barbara Kruger
Untitled (We Don't Need Another Hero), 1987
Screenprint on vinyl,
276.5 × 531.3 × 6.4 cm
(108⅞ × 209¼ × 2½ in.)

The visual fluency of Kruger's conceptual work encourages us to question the way women are represented and defined by advertising and the media. She is interested in doubt and resistance and the ways class and race have worked to marginalize people.

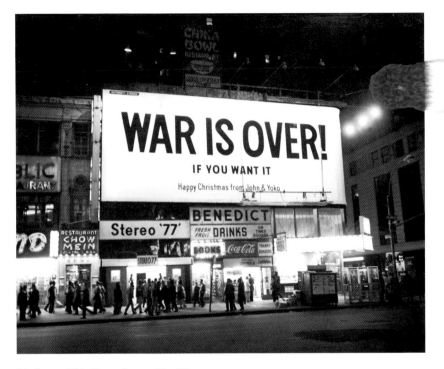

John Lennon & Yoko Ono
WAR IS OVER, if you want it, 1969
Billboard

Between 25 and 31 March 1969, newlyweds John Lennon and Yoko Ono held a bed-in for peace at the Hilton Hotel in Amsterdam. Occurring during the height of the Vietnam War, hundreds of people came to see the couple during their week-long protest. In December of that year, the couple continued to advocate for peace on billboards across eleven cities worldwide.

mock advert for Toyota, featured a white SUV above a line of skulls and the explanation that the company was ranked tenth worst in the world for its climate policy. As they say in their manifesto: 'We steal this space (from capitalism) and we give it back to you for free for the communication of possible futures.'

GRAFFITI

Brandalism's work operates in the same territory as graffiti and street art. For decades graffiti artists have contested corporate and political control of public spaces by leaving their mark in the form of tags, images and direct messages. The power of graffiti is in its accessibility: anyone can see it by walking down the street, there is no need to enter a gallery or a private space.

The relationship between graffiti and the art world is often contentious and rarely clear-cut, with graffiti artists challenging who decides what is and is not art and who gets to exhibit within its structures. This was made starkly apparent in 2008 at the São Paulo Biennial, when forty graffiti artists broke into the exhibition pavilion on the opening day and spray-painted the walls. The Biennial foundation took legal action and the taggers were arrested; one of them, Caroline Pivetta da Mota, spent almost two months in jail.

The No+ sign was a simple yet effective act of subversion.

For the Chilean artists associated with the Collective for Art Actions (CADA) in the late 1970s, the aim was to interrogate the relationship between art and politics under the brutal realities of General Pinochet's dictatorship. CADA were responsible for one of the most ingenious agitprop symbols in modern history, the No+ sign. The symbol, which means No More, was conceived by the artist Lotty Rosenfeld when she turned the white dashed lines running down the centre of a road into crosses – thereby transforming a minus into a plus symbol. It was a simple yet effective act of subversion.

CADA's next act was to graffiti the No+ sign across Santiago and then invite the citizens of the Chilean capital to anonymously voice their protest by completing the phrase. Their responses were abundant and varied, denouncing police brutality, the incarceration of political prisoners, domestic abuse and poverty. No+ became an increasingly powerful anti-Pinochet symbol, and in 1988 it was

Overleaf: CADA (Colectivo Acciones de Arte: Raul Zurita, Fernando Balcells, Diamela Eltit, Lotty Rosenfeld and Juan Castillo), *No+*, 1983 Documentation of live action, dimensions variable

CADA were a group of guerrilla activists who used happenings to challenge General Pinochet's brutal regime. Much of their work took the form of spontaneous street actions that would disrupt the normal activity of daily life and force the viewer to question authority.

central to the referendum campaign that led to the dictator being ousted from power. For generations of Chileans since then, it has served as shorthand for discontent with the ruling elite.

One of the most widely recognized images of the revolution that overthrew the Somoza family dictatorship in Nicaragua in 1979 is a photograph by Susan Meiselas of a gun-toting rebel from the Sandinista National Liberation Front hurling a Molotov cocktail. It was soon adopted by street artists and widely reproduced as a symbol of popular support for the new, left-wing Sandinista regime. 'Molotov man' has since appeared in a multitude of contexts, not least on T-shirts worn by members of the Nicaraguan student movement in the 2010s, opposed to the increasingly authoritarian government of Daniel Ortega, himself a Sandinista and former revolutionary leader.

Guerrilla Girls
Do women have to be naked to get into the Met. Museum?, 1989
Screenprint on paper,
28 × 71 cm (11⅛ x 28in.)

A large-scale study in the US in 2014 revealed that just twelve per cent of artists in museum collections were women and only one per cent were women of colour. Since then, things have begun to change, with recent rehangs in museums aiming for gender parity.

READ THE STATISTICS!

Statistics do not just describe reality, they can change it. The Guerrilla Girls are an all-female collective formed to fight the art world from within by gathering statistical data to expose the stark gender and racial inequalities that exist in museums and galleries. In 1989, they distributed a poster of a nude woman wearing a gorilla mask with the headline: 'Do women have to be naked to get into the Met Museum?' The poster went on to explain that fewer than one in twenty of the artists in the Metropolitan Museum of Art's Modern Art sections were women, but that seventeen out of every twenty painted nudes in the collection were female. Another poster proclaimed, 'You're seeing less than half the picture without the vision of women artists and artists of color', and invited '$ and comments' to be sent to a PO box address.

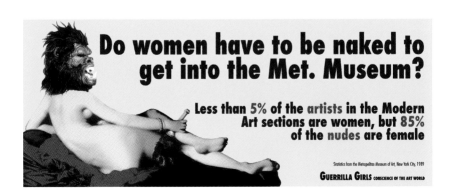

The Guerrilla Girls' assault on the art establishment grew out of feminist protest movements of the 1960s. As part of the campaign to increase female representation in New York's Whitney Museum of American Art, the Ad Hoc Women's Artists' Committee – founded by the curator Lucy R. Lippard and the artists Poppy Johnson, Faith Ringgold and Brenda Miller – distributed fake flyers in the lead-up to the opening of the gallery's 1969 Painting and Sculpture Annual. These announced that fifty per cent of all the exhibits were by women, forcing the Whitney's directors to issue a public statement of correction: the true figure was much lower. Although the protest was a success, the representation of women only rose from five per cent to twenty per cent the following year.

Howardena Pindell has used statistical data to protest against racism in the art world. Over the two-year period from 1986 to 1987 she gathered data on the number of artists of colour exhibiting in US museums and galleries. The results made for grim reading. Nearly all the exhibitions surveyed were 100 per cent white, and galleries represented few artists of colour.

More recently, the Moscow-based feminist street artist Mikaela has highlighted gender discrimination in her stencils featuring statistical data on inequality in Russia. The bright, graphic visuals of *Every Fourth Family* (2013) reveal the shocking truth that one in every four women in Russia experiences spousal abuse, and go on to provide helpline phone numbers for victims of domestic violence.

WHO WILL BUILD THE ARK?

In 2019, as some 2.5 million acres of the Amazon rainforest were going up in flames, President Macron of France tweeted 'Our house is burning. Literally.' The politician's stark response to the alarming news echoed the warning calls of climate activists such as the Polish-Brazilian artist Frans Krajcberg, who has protested at the destruction of the rainforest in a series of blackened wood sculptures: 'I do not try to sculpt; I seek shapes for my cry. This burnt husk is me,' he said in an interview with *Art Focus* magazine in 1999. Since the birth of the modern environmental movement in the 1960s, the human impact on ecosystems and the landscape has been an important focus for artistic production. Conversely, artists have often been central to the climate protest movement through their ability to represent the crisis so vividly.

Climate artist-activists such as Gustav Metzger have protested at the destructive effects of pollution on the natural world through sculptures such as *Mobbile* (1970). This took the form of a car with

Simryn Gill
Channel #13, 2014
Channel #19, 2014
Photographs, dye destruction on paper, each 31.9 × 31.6 cm (12⅝ × 12½ in.)
Tate, London

Gill's dye-destruction photographs of a mangrove forest riddled with plastic waste on the coast of Port Dickson in Malaysia are used to reflect the transitory world of migration and exportation and the detritus left behind.

a Perspex box on its roof, connected to the vehicle's exhaust and containing a live plant; as the engine ran, the box collected the emissions, poisoning the plant and coating the Perspex with a vile black residue. In 2008, towards the end of his life, he launched the campaign Reduce Air Flights (RAF) in response to the massive commercial growth of the global art industry.

In 1972, the West German artist Hans Haacke took on the city of Krefeld, in order to expose the pollution of the Rhine caused by the local sewage plant. He diverted some of the contaminated river water into Krefeld's Museum Haus Lange, where it ran through a makeshift filtering system. The cleansed water went into a fish tank, while the grey water was used to irrigate the museum's garden and the extracted sewage was displayed in glass bottles. Haacke's *Rhinewater Purification Plant* caused outrage and protests at the environmental destruction symbolized. While the installation revealed the exploitation of the Rhine by powerful corporations, it also provided a potential solution, fostering hope for the future.

-

In the late 1960s Joseph Beuys decided that his art actions needed to become 'real undertakings' that could wield political power.

-

Until the late 1960s, Joseph Beuys had used art to excavate Germany's unspeakable recent past, devising earthy, ritualistic performances that might heal the country's trauma. But in the context of the era's widespread social unrest, he decided that his art actions needed to become 'real undertakings'. Beuys had always believed that art and politics were intimately linked. Now, he wanted to understand what art should or could accomplish in the world as the expression of political power. The problem, as he saw it, was a crisis of representation. Political parties had become so reliant on

Previous spread:
Tania Bruguera
UNNAMED, installation view for the 22nd Sydney Biennale, 2020

In UNNAMED, participants had the name of a murdered environmental defender tattooed on their arm. The tattoo had no ink and disappeared after a short while, a symbolic act to commemorate those killed whilst attempting to protect the environment.

Sammy Baloji
Untitled 17, from *Memory*, 2006
Large format colour photograph montage

Baloji's art is a visual history of Katanga Province in the Democratic Republic of Congo. Through his photomontages he weaves together a narrative about the destruction of the environment and the trauma inflicted on its inhabitants through industrialization, colonialism and war.

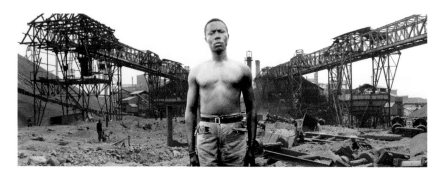

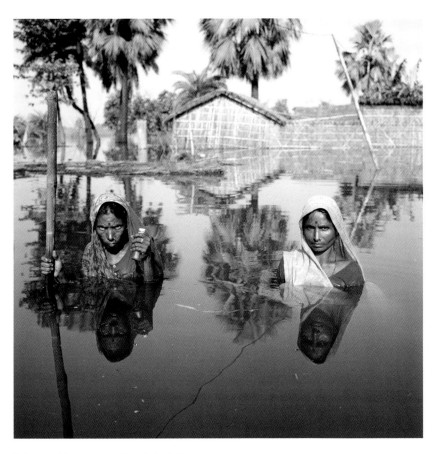

Gideon Mendel
Chinta and Samundri Davi,
from *Drowning World,*
Submerged, Portraits, India,
2007

Mendel's classically
composed portraits
of people standing in
flood water speak of
the shared anxieties
and vulnerabilities of
communities across the
world. The photographs
are taken in the aftermath
of tragedy, once the
event has happened and
the news has moved on,
showing those who have
been left with the trauma
of piecing their lives back
together again.

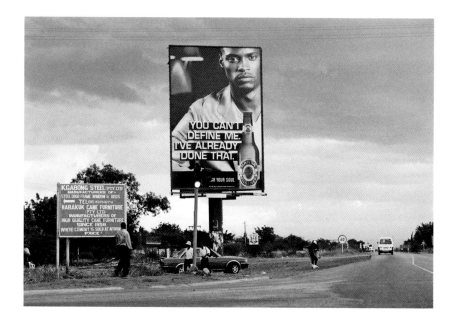

their financial backers that they had ceased to represent the will of the people. So he began founding organizations that might grow large enough to wield significant power on the people's behalf. Over the next eight years he established the German Student's Party, the Office for Direct Democracy and the Free International University as well as, in 1980, with 500 others, the German Green Party. Posters for Beuys's 1984 show 'What is to be Done?' (a reworking of the communist leader Lenin's famous revolutionary cry) showed him plunging a garden fork into the earth in front of a nuclear power station.

Beuys's belief that art can be a catalyst for political change has inspired the Cuban activist Tania Bruguera, who believes that artists should be active and engaged citizens who create art that is useful to society. In 2020, she temporarily tattooed participants with the names of activists killed whilst trying to protect the environment. Mindful that the overwhelmingly complex issues surrounding climate change can induce a sense of helplessness, she brought the issue down to a human level by reminding people that individual actions matter.

It was that humanity that shocked the world in 1986 when Sebastião Salgado published his pictures of mud-soaked workers clambering up the side of the open cast gold mine at Serra Pelada in Brazil. The images, part of a wider photographic project that

Santu Mofokeng
A Roadside Sign in Tshwane, Marabastad / Hammanskraal, c. 2008, printed 2011
Photograph, gelatin silver print on paper, 29.8 × 45 cm (11¾ × 17¾ in.)
Tate, London

Mofokeng's *Billboards* series, made between 1991 and 2009, focused on the disparities between roadside advertising and real life in South Africa.

scrutinized manual workplace conditions, were compared to Hieronymus Bosch and Dante's *Inferno*.

In post-apartheid South Africa, the photographer Santu Mofokeng, a member of the Afrapix collective, turned his camera on the environment. He traced the trauma of his country's recent past through images of the land used for mining operations. Sammy Baloji also exposes the ravages of industrial mining on the countryside in his photographs of Katanga province in the Democratic Republic of Congo. His photomontages superimpose archival images from the colonial period over contemporary images of the landscape. Baloji's art is concerned with the ongoing impact of colonialism on his homeland, as seen in the plundering of uranium ore and other mineral resources by global corporations. 'In colonialism you can also find the beginning of capitalism itself,' he said to *Studio International* in 2019.

Gideon Mendel, a South African photographer, has presented an apocalyptic vision with his *Drowning World* series (2007), which includes portraits of people in flood zones with their heads just above the water level in order to convey the impact of climate crisis on people's lives.

In recent years, artists and activists have used digital platforms to spread their message. Molleindustria are an Italian collective who created the satirical video game *Phone Story* (2011), in which the player follows the 'troubling supply chain' behind smartphones, from child labour in a Congolese coltan mine to suicidal factory workers in China. The game was banned by Apple hours after its release, triggering public debate about how big business responds to criticism and the insidious control digital platform owners and smartphone companies have over society.

KEY QUESTION

Can protest art change people's minds?

Molleindustria
Phone Story, 2011

The Italian collective confronts the extractive, capitalist nature of the technology industry. Their manifesto states that 'Molleindustria was born in the soft core of Capital's processes of valorization...daughter of cognitive labor, of shared information, of entertainment that becomes politics and vice versa'.

LIVING IN TRUTH

-

Every epoch, in fact,
not only dreams the one to follow,
but in dreaming,
precipitates its awakening.

-

Walter Benjamin, Exposé of 1935, 1935

Pussy Riot
Performance in front of
St Basil's Cathedral, Red
Square, Moscow, 2012

Underground punk art
activists Pussy Riot use
their music to criticize
organized religion, the
corruption of the state,
misogyny and censorship
in Russia. For this
performance, they took
their protest songs to
the symbolic heart of
the state, Moscow's Red
Square.

PURE PROTEST

In 2008, on the eve of Dmitry Medvedev's election to the Russian
presidency vacated by Vladimir Putin, the satirical art collective
Voina (War) staged *Fuck for the Heir Puppy Bear!*, in which five
couples had sex beside a stuffed bear in the State Museum of
Biology in Moscow in protest at government corruption. As
Voina member Alexi Plutser-Sarno said of the work at the time:
'Everybody fucks each other, and the puppy bear [a nickname for
Medvedev] looks on with an unconcealed scorn.'

The Voina members Nadezhda Tolokonnikova and Yekaterina
Samutsevich established the all-female performance art group
Pussy Riot in 2011 to expose Vladimir Putin's aggressive imperialist
politics. Their concerts, for which they wear brightly coloured masks
and tights, are loud and visually striking. Aside from Tolokonnikova,
Samutsevich and Maria Alyokhina, whose names were revealed
following their arrest for a performance in Moscow's Cathedral of
Christ the Saviour in 2012, Pussy Riot are anonymous, arguing that
they are not individuals but an idea of 'pure protest': truth-tellers to
the Russian nation. Pussy Riot embody a condition articulated by
the Czech dissident writer and later President Václav Havel in 1978
as 'living in truth', describing the power wielded by the powerless.

During the Cold War, artists in communist Eastern Europe were
confronted with a bleak choice: forego creative experimentation
and self-expression in order to extol the joys of communism in
state-approved Socialist Realist art, or be driven underground.
Those who refused to participate in the lies of the regime deployed
avant-garde tactics to survive. Art took the shape of performances
and happenings in private apartments or in venues that were difficult
to find and could not be reused. Publicity was nonexistent and
events were announced by word of mouth. In such an environment,
the act of creation could easily be (and often was) construed by the
authorities as a provocation or a protest to be ruthlessly suppressed.

One such confrontation happened on 15 September 1974, when
over thirty non-conformist artists decided to hold an open-air
exhibition in a field on the outskirts of Moscow. The event was
sabotaged by the city's authorities, who despatched bulldozers,
dump trucks and the police to the site to destroy the artworks and
arrest the organizers. The affair became known as the Bulldozer
Exhibition and the international outcry following the imprisonment
of the organizers led the authorities to back down and issue a permit
allowing another open-air contemporary art show. But victory
was short-lived. Many of the artists associated with the Bulldozer
Exhibition were forced to emigrate; others died prematurely.

The Orwellian permanence of surveillance is something that the dissident Chinese artist Ai Weiwei has come to expect in a career that has been openly critical of the Chinese government. In 1997, he photographed himself giving the middle finger in Beijing's Tiananmen Square (*Study of Perspective, Tiananmen*, 1995). He has continued in the same spirit ever since. In 2008, an earthquake in Sichuan province killed 5,000 children when their school buildings collapsed. Ai helped establish a citizens' investigation into the deaths of the children, whose names had been withheld by the authorities. The schools were poorly constructed by corrupt contractors using substandard concrete and the children stood no chance of survival. Ai gathered the names of the dead and displayed them publicly along with the steel reinforcement bars from the destroyed buildings that had failed to keep them safe. The children's names were also printed on the wall of Ai's studio and published on his blog.

-

The Orwellian permanence of surveillance is something that the dissident artist Ai Weiwei has come to expect in a career that has been openly critical of the Chinese government.

-

The protest cost the artist. In 2009 he was beaten up by the police, suffering a cerebral haemorrhage as a result. In 2011, he was secretly detained without formal charges for three months before being placed under constant surveillance. Today Ai lives in exile, like many dissident artists from totalitarian regimes, including some of Pussy Riot's members. In a recent interview in *Christie's Magazine*, he ruminated on what it was like to 'live in truth':

> I never thought that I could 'live in truth', but I always thought that truth encompasses inner truth and cosmic patterns. Truth is like gravity; I can hardly imagine how I can surpass it and exist without it. No matter how I fantasise and struggle, it still determines my behaviour.

THE METAPHYSICAL PROTEST

One day in 1965, a puzzling manifesto was distributed on the streets of Bratislava, in what was then communist Czechoslovakia. From now on, it announced, life itself was a work of art. The flyer claimed possession of the next nine days of socialist celebrations and

Overleaf: Ai Weiwei *Straight*, 2008–2012, at the Royal Academy of Arts, London. Steel reinforcing bars.

In 2008, Ai's blog on Sina Weibo was shut down when he criticized corrupt government officials over the deadly collapse of over 7,000 poorly constructed schoolrooms in Sichuan during an earthquake. *Straight* consists of reinforcing bars salvaged from these buildings, straightened by hand. In 2011 he was arrested for attempts to investigate the casualties; on his release eighty-one days later he uploaded the K-pop parody, 'Grass Mud Horse Style', a message of defiance to the Chinese authorities.

Washington, DC.
A protester faces soldiers
near the Pentagon, on 21
October 1967

**Protester Jan Rose
Kasmir was seventeen
years old when she
attended the March
on the Pentagon. She
described noticing
that day how young
the soldiers were, and
how much they, too,
were victims of the war
machine.**

official parades from Workers Day on 1 May to Soviet Liberation
Day on 9 May. The entire city of Bratislava was now an artwork
entitled *HAPPSOC 1* – a name which combined the words 'happy',
'happening' and 'society', in ironic reference to the propaganda
promulgated by the authorities. The group responsible for this
performance were also called HAPPSOC, and their intention was
to wrest creative freedom from communist state control. Stano
Filko, one of the artists behind the protest, recognized that under
a totalitarian regime, defiance had to be invoked through radical
imaginative acts. The HAPPSOC group went on to promote space
travel and the cosmos as a place of creative possibility.

Metaphysical protests were not confined only to totalitarian
states, however. Two years later, in 1967, the United States
government was put in the humiliating position of ordering out
troops to defend the Pentagon from the absurd threat of an
exorcism. A group of cultural activists had declared their intention
to levitate the vast building three hundred feet in the air as part
of an anti-Vietnam War demonstration. Watched by the media,
soldiers stood resolutely on guard while protesters – among them
such countercultural stalwarts as Abbie Hoffman, the charismatic
leader of the Yippie movement, and the poet Ed Sanders –
performed an elaborate ritual exhorting God to rid the Pentagon of
its demons. The comedy of the spectacle did much to popularize the
peace movement. As the Beat poet Allen Ginsberg noted in *Arthur*

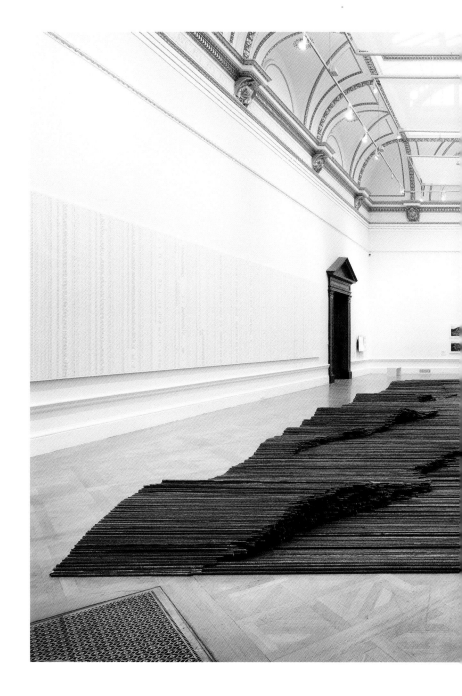

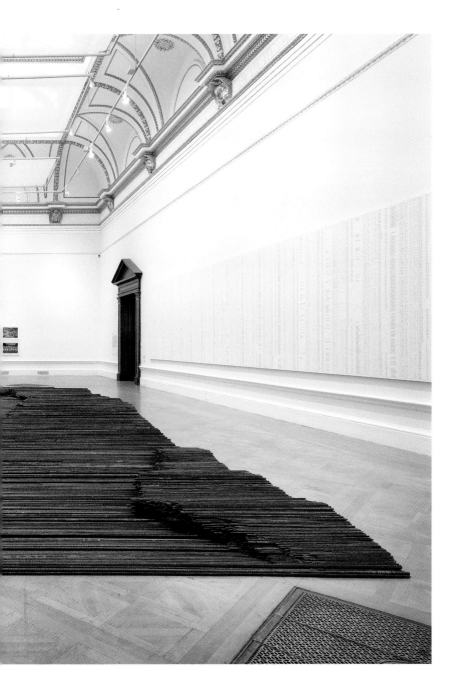

Dear Friend,
I am black.
I am sure you did not realize this when you made/laughed at/agreed with that racist remark. In the past, I have attempted to alert white people to my racial identity in advance. Unfortunately, this invariably causes them to react to me as pushy, manipulative, or socially inappropriate. Therefore, my policy is to assume that white people do not make these remarks, even when they believe there are no black people present, and to distribute this card when they do.
I regret any discomfort my presence is causing you, just as I am sure you regret the discomfort your racism is causing me.

magazine in 2004, it 'demystified the authority of the military'. In that sense 'the Pentagon was symbolically levitated in people's minds'. When the novelist and journalist Norman Mailer came to record the remarkable event in his semi-fictional account *The Armies of the Night* (1968), he wrote that the protesters marched on the Pentagon 'not to capture it, but to wound it symbolically'.

Adrian Piper
My Calling (Cards) #1 (Reactive Guerrilla Performance for Dinners and Cocktail Parties), 1986–present
Performance prop: brown printed card, 5.1 cm x 9 cm (2 x 3½ in.)

NO!

The artist Gustav Metzger gained his reputation as a provocateur predominantly for his anti-capitalist gestures against global corporate power. Art was a serious calling for Metzger; he was repelled by Pop Art's celebration of the commercial and objected to the ravages of the commercial market that sought to manipulate art for profit. Disillusioned, he increasingly found that art no longer held the promise of revolution.

In 1974, Metzger was invited to participate in an exhibition at the Institute of Contemporary Art in London entitled 'Art into Society/Society into Art'. His contribution took the form of a proposal. If 'art in the service of revolution is unsatisfactory and mistrusted because of the numerous links of art with the state and capitalism', he wrote, then artists must use the chief weapon of all workers fighting the system: withdraw their labour en masse – in this instance, for no less than three years . This would cripple an entity reliant on the ceaseless circulation of artists, artworks, money and information. Museums and cultural institutions would close, art

Piper began addressing social boundaries and personal identity in the context of a violently racist society following the US intervention in Vietnam and the ongoing struggle for civil rights. The *Calling Cards* draw attention to the dynamics of race and gender in social situations.

magazines stop publishing and dealers go out of business. 'Damage
one part, and the effect is felt world-wide,' Metzger reasoned. 'The
deep surgery of the years without art will give art a new chance.'
In the end, no one signed up to his *Years without Art, 1977–80,* and
so he went on strike on his own.

**Metzger objected to the art market that sought to manipulate
art for profit.**

Such withdrawal from the art world is an example of protest
through the refusal of dialogue, or a rejection of the terms of
engagement. It was the method adopted by the African American
artist David Hammons in the mid-1970s when he made a leap
for freedom, ditching the art gallery for the streets of New
York's specifically Black neighbourhoods, where he performed
actions and exhibited sculptures made out of street detritus. This
rejection of a system he considered racist and elitist eventually
served him well. He returned to the gallery system on his own
terms in the 1990s, comfortably navigating the ruthless art world
with the simple demand that whatever he asked for, the answer
was 'yes'.

In 1986, Adrian Piper developed a simple and direct form
of protest at the way she was treated. As an American woman
of acknowledged African ancestry, who at the time identified
as black, she often found herself an 'unwilling witness to the
forms racism takes when racists believe there are no black
people present', as she put it in the periodical *Transition* in 1992.
In response she started to give out calling cards that explained
that she was black and objected to the racist comments made in
her presence. Piper was taking on the liberal art establishment
– those that did not think they had a problem. In her paper 'The
Joy of Marginality', delivered at 'The Ideology of the Margin:
Gender, Race and Culture', organized by the New Museum of
Contemporary Art, New York, on 11 May 1988, she wrote: 'My
work is an act of communication that politically catalyzes its
viewers to a target or stance that I depict.'

In 2021, a group of twenty-five artists 'de-authored' artworks
by themselves that had been bought by the Zabludowicz Collection,
London, in protest at the gallery's ties to the Israeli government.
This coordinated act of withdrawal from the collection, which came
after an upsurge of violence in the Israel–Palestine conflict, was not

an easy one. The Zabludowicz Collection is known for supporting young, up-and-coming artists – ones entirely lacking the standing that enables someone like Nan Goldin to hold a major art institution to ransom over its choice of billionaire sponsors. To promote their endeavour, the group have developed a website of statements by other artists and artworkers who have also refused to be involved with the gallery.

When the Russian collective Chto delat? (What is to be done?) withdrew from the Manifesta 10 biennial in St Petersburg in 2014 in protest at ongoing Russian military intervention in Ukraine, it triggered widespread debate about participation in large-scale state-sponsored art festivals. The debate was reignited in 2022, at Documenta 15 in Kassel, Germany, after it was discovered that an agitprop banner painted by members of the Indonesian art collective Taring Padi included two antisemitic figures. The banner, titled *People's Justice*, was intended to call to account all those who had collaborated in the past with President Suharto's long-lived authoritarian regime, including foreign intelligence services such as those of the UK and US. Documenta's director Sabine Schormann resigned, and the banner was first covered, then taken down. A row about the limits of artistic freedom, which had been simmering in the media since the inclusion in the exhibition of the Palestinian collective The Question of Funding and the cancellation of a panel discussion about antisemitism, erupted. The anticolonial discourse that had been intended was drowned out by further divisive accusations of antisemitism on one side and Islamophobia on the other, leaving no opportunity to acknowledge how profoundly the histories of both are entangled.

POST-REVOLUTIONARY TOIL

We live in a time of great uncertainty, and it seems the need for politically engaged art is more urgent than ever. Ironically, it is the very destabilizing and elusive aspects of art that Kant believed separated it from politics which make art so politically powerful today. The post-modern world is a messy and disorientating place and the political structures we encounter can often seem impenetrable and crazy. Is power challenged when it is unclear where precisely the power lies? In a world where cybernetics and digital technologies and artificial intelligence are changing everything, especially our perception of reality, what happens when the true power is not a state or a faceless institution but a

tech entrepreneur in charge of a global network of information systems?

Today's artists are agents of action, voicing through their work the concerns of the people.

In such a world, can art be a crack in the system? Can it counter the established discourse and be the revelation society is looking for? Today's artists are agents of action, voicing through their work the concerns of the people. The late Austrian curator Peter Weibel believed that artists have become more concerned with social and human agendas since the 1960s. Art, he argued in the book *Global Activism* (2015), 'forms the exile in which fundamental civil tasks can still be realized'.

The French philosopher Roland Barthes once complained that the problem with revolutionary writing was its lack of concern with how societies might live once revolution has triumphed. It is a view that John Lennon echoed in the pages of *Black Dwarf* in 1969, after that paper had published an open letter by the activist John Hoyland criticizing his song 'Revolution'. 'What kind of system do you propose and who would run it?' Lennon demanded of Hoyland, who had written that for change to happen, society had to understand what was wrong with the world and then destroy it – 'ruthlessly.'

So who is prepared to take on the burden of post-revolutionary toil once the dust has settled? *Big Bang 2* (2019) was the culmination of a year-long project by the British artists Hilary Powell and Dan Edelstyn to play the financial services industry at its own game. In 2018, following the example of Strike Debt, the decentralized debt resistance collective in the United States, the pair opened a bank in Walthamstow in north-east London. They printed their own money, and exchanged it for sterling, which they then used to buy up £1.2 million of local high-interest debt on the secondary debt market (where bad debt is traded for a fraction of its face value). This debt was then loaded into a gold Ford transit van, which was blown up on a wasteland opposite Canary Wharf, part of London's financial district, in what Powell described in the exhibition catalogue *Defaced, Money, Conflict, Protest* (2022) as an 'ethical, emancipatory spectacle'. The remnants of the van's contents were made into an artwork, making physical Karl Marx and Friedrich Engels's words from *The Communist Manifesto*: 'All that is solid melts into air.'

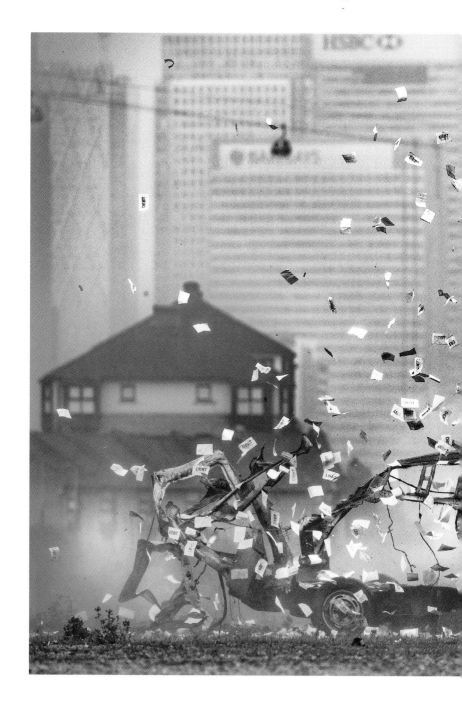

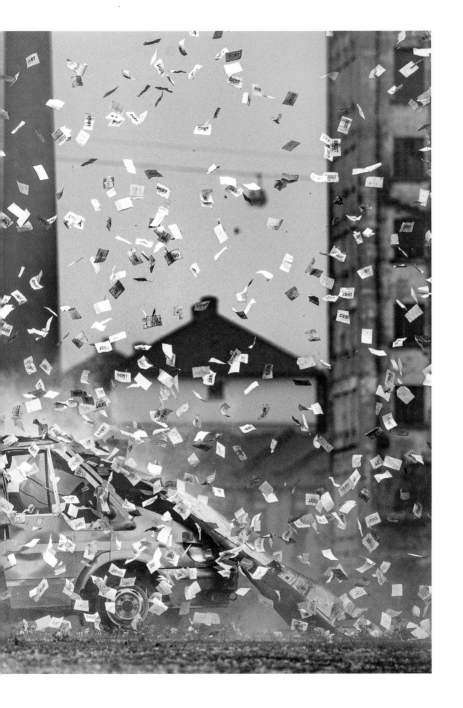

Out of the wreckage of *Big Bang 2* came POWER, a community interest company tackling social and economic issues through joyfully anarchic cultural productions. The initiative is one of many established in recent years by artists and art workers around the globe, such as the Sweet Water Foundation in Chicago, committed to the regeneration of the urban environment, the Hannah Arendt Institute of Artivism (INSTAR), which advocates for social justice in Cuba, and the Immigrant Movement International, which gives greater visibility to the plight of immigrants (both founded by Tania Bruguera), and the human rights artist agency Forensic Architecture in London. All are collectives run by artists who have looked at the societies we are living in and asked themselves: why? And they are now responding with what the nineteenth-century artist and socialist visionary William Morris would have described as 'useful work' – work that is as urgent now as ever.

Previous spread: Hilary Powell and Dan Edelstyn *Big Bang*, 2: The Explosion of the debt in transit van, 19 May 2019. Photograph by Graeme Truby-Surety

Hilary Powell and Dan Edelstyn staged *Big Bang 2* opposite Canary Wharf in London's docklands, an area that was transformed in the 1980s from a wasteland into a thriving financial district following the introduction of financial deregulation by Margaret Thatcher's Conservative government – a move that became known as The Big Bang.

Forensic Architecture
Still from *Herbicidal Warfare in Gaza*, 2019, part of *Cloud Studies*, 2021

KEY QUESTION
How can protest art help to transform society?

Cloud Studies investigates different types of toxic cloud caused by airborne chemicals such as chlorine, herbicides and tear gas. It reveals the extent to which our atmosphere has been poisoned by state and corporate powers. Clouds also serve as a metaphor for our 'post-truth' world, in which deceit obscures acts of violence. 'We the inhabitants of toxic clouds must find new ways of resistance,' write Forensic Architecture.

GLOSSARY

Anti-capitalism: Movements and ideologies that seek an alternative economic system to capitalism, which is based in private property and competition.

Artist Manifesto: Meaning 'a piece of evidence', from the Latin *manifestare*, an artist manifesto is a written document that outlines the desires/beliefs/intentions of the artist/s.

Black Lives Matter: An international activist organization founded in the United States in 2013 that seeks to combat and counter racism, racial inequality and racist violence, including by the state and its police force.

Black Panther Party: A radical political movement that connected the oppression of Black people in America to people of colour across the globe, linking the internal struggle against racism in the United States to anti-imperial struggles in Africa, Asia and Latin America.

Civil Rights Movement: A non-violent Black revolution in the United States led by Martin Luther King Jr, which brought three centuries of legally enshrined, lethally enforced white supremacy to a constitutional end.

Colonialism: The military power of a nation dominating another nation by economic, political and psychological oppression.

Coup: The sudden, often violent, overthrow of a government by a small group.

Dada: An avant-gardist group formed in Zurich in 1915 dedicated to the destruction of traditional art forms.

Feminism: Movement/s and ideologies that aim to define and achieve equal rights for women.

Fluxus: A conceptual international art movement coordinated by George Maciunas in the early 1960s with a focus on performance, chance and repetition.

Futurism: An Italian art movement founded in 1909. The group advocated for the destruction of traditional culture and art institutions in favour of a super-animated art that embraced the new – fast cars, rapid gun fire and electricity. Paintings conveyed speed and dynamism as waves of energy.

Guantanamo Bay detention camp: A United States military detention centre on the coast of Guantánamo Bay in Cuba, where citizens captured in Afghanistan and Iraq were held without being charged and without access to legal counsel.

Irish Republican Army (IRA): An Irish nationalist military force that emerged in 1919 to fight for Irish independence from British rule.

Military junta: A government run by a group or committee of military leaders, often after a coup.

Modernism: Coined by the poet Ezra Pound in 1922 to define a new world, a movement forged on technology, radical uncertainty and a desire to cast off the past that had brought forth the horrors of the First World War.

Molotov Cocktail: A makeshift bomb constructed out of a glass bottle filled with flammable liquid and a wick that is lit before throwing.

Neo-colonialism: An imperialism that would rather not invade or conquer another country if it can dominate or exert pressure by economic, political or cultural influence.

Orwellian: Inspired by the dystopian novel *1984* by George Orwell, an adjective used to describe a situation or an idea that is oppressive or destructive to the welfare of a free and open society.

Photomontage: A collage constructed from photographs. First formalized by the Dadaists as a form of anti-art during the First World War.

Post-modernism: An open-ended cultural condition that transgressively mixes high and low culture. It entered the lexicon in the late 1970s, during a period when philosophers were questioning the existence of objective facts and asking if there was such as thing as a universal 'truth'.

Propaganda: A political strategy to manipulate public opinion, often achieved with powerful slogans or artistically in more subtle ways, such as making ordinary figures seem heroic.

Quit India Movement: A movement launched by the Congress of India in August 1942 demanding immediate independence from Britain. Millions took part in demonstrations and thousands of activists and leaders were sent to jail, including Mahatma Gandhi and Jawaharlal Nehru.

Realpolitik: A system of politics based on practical considerations rather than moral ones.

Referendum: A vote on a single political question with few fixed requirements or rules, the result of which is not binding.

Roe v. Wade: A landmark decision of the United States Supreme Court in 1973 that ruled that the US Constitution protected women's right to choose to have an abortion free of interference by the state.

Satyagraha: A policy of non-violent resistance devised by the civil disobedience leader Mahatma Gandhi to drive the British from India.

Situationist International: An international art movement founded in Italy in July 1957 as a critique of modern capitalism and its alienating social processes. The members shared the belief that contemporary avant-garde art groups had betrayed their original commitment to revolution.

Surrealism: An international artistic and literary movement established by André Breton in Paris in 1924 that explored automatism, dreams, the unconscious and the uncanny to connect personal freedom to social liberation through revolutionary desire.

Vorticism: A modern art movement founded in July 1914 by the British artist and writer Wyndham Lewis in which he called for 'a new living abstraction'. It was typified by hard lines and simplified volumes, and the breakdown of objects into geometrically distorted elements.

FURTHER READING

Rasheed Araeen, *Making Myself Visible* (London: Third Text Publications, 1984)

Simon Armstrong, *Street Art* (London: Thames & Hudson, 2019)

Guy Brett and David Medalla, *Exploding Galaxies: The Art of David Medalla* (London: Kala Press, 1995)

Eddie Chambers, *World is Africa: Writings on Diaspora Art* (London: Bloomsbury, 2021)

Doryun Chong, Michio Hayashi, Fumihiko Sumitomo and Kenji Kajiya (eds), *From Postwar to Postmodern, Art in Japan, 1945–1989: Primary Documents* (Durham, NC: Duke University Press, 2012)

Henry Cole, *Gustav Metzger: In Retrospect* (exh. cat.; Oxford: Museum of Modern Art Oxford, 1999)

Elizabeth Crawford, *The Women's Suffrage Movement: A Reference Guide 1866–1928* (Oxford: Routledge, 2000)

Katy Deepwell, *Feminist Art Activisms and Artivisms* (Amsterdam: Valiz, 2020)

Emory Douglas, *Black Panther: The Revolutionary Art of Emory Douglas* (New York: Rizzoli International Publications, 2013)

Ibrahim El-Salahi, *At Home in the World: A Memoir*, ed. Salah M Hassan (Milan: Skira editions, 2021)

Frantz Fanon, *The Wretched of the Earth* (London: Penguin Modern Classics, 2001)

Avram Finkelstein, *After Silence: A History of AIDS Through its Images* (Berkeley, CA: University of California Press, 2017)

Catherine Flood and Gavin Grindon, *Disobedient Objects* (exh. cat.; London: V&A Publishing, 2014)

Tatiana Flores, *Mexico's Revolutionary Avant-Gardes: from Estridentismo to !30-30!* (New Haven, CT: Yale University Press, 2013)

Maja Fowkes and Reuben Fowkes, *Central and Eastern European Art Since 1950* (London: Thames & Hudson, 2020)

Mahatma Gandhi, *Hind Swaraj* (Phoenix: The International Printing Press, 1909)

Terri Geis, 'Myth, History and Repetition: André Breton and Vodou in Haiti', *South Central Review* 32/1 Special Issue: *Dada, Surrealism and Colonialism*, 56–75

Mark Godfrey and Zoe Whitley, *Soul of a Nation: Art in the Age of Black Power* (exh. cat.; London: Tate Publishing, 2017)

David Graeber, 'On the Phenomenology of Giant Puppets', *The Anarchist Library*, 2007

Jonathan Harris, *Terrorism and the Arts: Practices and Critiques in Contemporary Cultural Production* (Oxford: Routledge, 2021)

Matthew Higgs, *Protest and Survive* (exh. cat.; London: Whitechapel Art Gallery, 2000)

Abbie Hoffman, *Steal This Book* (New York: Pirate Editions/Grove Press, 1971)

Laura Hoptman and Tomáš Pospiszyl (eds), *Primary Documents: A Sourcebook for Eastern and Central European Art since the 1950s* (New York: The Museum of Modern Art, 2002)

Inés Katzenstein, *Listen Here Now! Argentine Art of the 1960s: Writings of the Avant Garde: Primary Documents* (Durham, NC: Duke University Press, 2004)

Clive Kellner and Sergio-Albio González (eds), *Thami Mnyele & Medu: Art ensemble retrospective* (Johannesburg: Jacana Media, 2009)

Robert Klanten, *Art & Agenda: Political Art and Activism* (Berlin: Die Gestalten Verlag, 2011)

Jessica Lack, *Why Are We 'Artists'? 100 Art World Manifestos* (London: Penguin Modern Classics, 2017)

Anneka Lenssen, *Sarah Rogers and Nada Shabout, Modern Art in the Arab World: Primary Documents* (New York: The Museum of Modern Art in assocation with Duke University Press, 2018)

Norman Mailer, *The Armies of the Night: History as a novel, a novel as history* (London: Penguin Modern Classics, 1968)

Javier Marías, *To Begin at the Beginning* (London: Sylph Editions, 2020)

Anna McNay, 'Margaret Harrison: You have to work a strategy to draw people into the work', *Studio International*, 6 January 2016

Gustav Metzger, *Auto-Destructive Art: Metzger at AA* (London: Architectural Association Publications/Bedford Press, 2015)

Walker Mimms, 'Rupert bare: how the Oz obscenity trial inspired a generation of protest art', *The Guardian*, 4 August 2021

Amy Mullin, 'Feminist Art and the Political Imagination', *Hypatia*, 18/4 Women, Art and Aesthetics, Autumn/Winter 2003, 189–213

Darren Pih, *Radical Landscapes: Art, identity and activism* (exh. cat.; London: Tate Publishing, 2022)

Adrian Piper, *Adrian Piper* (exh. cat.; Birmingham: Ikon Gallery; Manchester: Cornerhouse, 1991)

Diego Rivera, 'The Revolutionary Spirit in Modern Art', *The Modern Quarterly*, 6/3, Fall 1932, 51–7

Siobhán Shilton, *Art and the Arab Spring: Aesthetics of revolution and resistance in Tunisia and beyond* (Cambridge: Cambridge University Press, 2021)

Peter Weibel, *Global Activism: Art and Conflict in the 21st Century* (Cambridge, MA: MIT Press, 2014)

Linda Weintraub, *To Life!: eco art in pursuit of a sustainable planet* (Berkeley, CA: University of California, 2012)

Gennifer Weisenfeld, *MAVO, Japanese Artists and the Avant-Garde, 1905–1931* (Berkeley, CA: University of California Press, 2002)

INDEX

Illustrations are in *italics*

PICTURE ACKNOWLEDGMENTS

First published in the
United Kingdom in 2024 by
Thames & Hudson Ltd, 181A High
Holborn, London WC1V 7QX

First published in the United States
of America in 2024 by Thames &
Hudson Inc., 500 Fifth Avenue,
New York, New York 10110

Design by April

British Library Cataloguing-in-
Publication Data
A catalogue record for this book is
available from the British Library

Library of Congress Cataloguing-
in-Publication Data
A catalogue record for this title has
been requested

ISBN 978-0-500-29668-4

Printed and bound in Bosnia and
Herzegovina by GPS Group

Be the first to know about our
new releases, exclusive content
and author events by visiting
thamesandhudson.com
thamesandhudsonusa.com
thamesandhudson.com.au

Front cover: Ai Weiwei, *Study of Perspective – Tiananmen Square*, 1995. Courtesy
of Ai Weiwei Studio.

Chapter openers: page 2 Michael Rakowitz, *The Invisible Enemy should not
exist (Room H, Northwest Palace of Nimrud) H-17*, 2020 (detail from page 121);
page 4 Abu Bakarr Mansaray, *Terrific Poisonous and Hostile*, 2006 (detail from
page 94); **page 8** Sahar Ghorishi, *Jina Mahsa Amini – for Women, Life, Freedom*,
2022 (detail from page 14); **page 24** Anita Steckel, *N.Y. Canvas Series #2* , c. 1971
(detail from page 35). Tate London; **page 44** Farid Belkahia, *Cuba si*, 1961 (detail from page 53).
Tate London; **page 60** VALIE EXPORT, *Aktionshose, Genital Panic*, 1969 (detail
from page 66); **page 82** Malangatana Ngwenya, *Untitled*, 1967 (detail from page
94). Tate, London; **page 96** Inji Efflatoun, *Portrait of a Prisoner*, 1959 (detail from
page 101). Mathaf, Museum of Modern Art, Doha; **page 110** PAIN protesting
the Arthur M. Sackler Museum, Harvard Art Museum, July 2018 (detail from
page 124-125); **page 128** Simryn Gill, *Channel #19*, 2014 (detail from page 143).
Tate London; **page 152** Hilary Powell and Dan Edelstyn, *Big Bang, 2: The Explosion
of the debt in transit van*, 19 May 2019. Photograph by Graeme Truby-Surety (detail
from pages 164–65).

Quotations: page 9 Gustav Metzger, 'Manifesto World' [7 Oct 1962], London,
October 1962, first distributed at the Misfits evening at the ICA London, 24
October 1962. Reprinted in Metzger, 'Auto-Destructive Art', London, 1965;
reprinted in *Theories and Documents of Contemporary Art*, 2nd ed., ed. Kristine
Stiles and Peter Selz (Berkeley: University of California Press, 2012), pp. 472–73;
page 25 Tristan Tzara, 'Dada Manifesto 1918', 23 March 1918; **page 45** Georges
Henein, Manifesto, 1945. Republished in *'Why Are We Artists'? 100 Art World
Manifestos*, selected by Jessica Lack (London: Penguin Modern Classics, 2017),
p. 156; **page 61** Amílcar Cabral, 'National Liberation and Culture', speech delivered
on 20 February 1970 as part of the Eduardo Mondlane Memorial Lecture series,
Syracuse University; **page 83** The Russell-Einstein Manifesto, 1955, issued 9 July
1955. Courtesy of the Atomic Heritage Foundation; **page 97** Richard Huelsenbeck,
'First German Dada Manifesto', delivered at the I. B. Neumann Gallery, Berlin,
February 1918. Translated by Ralph Mannheim; **page 113** F. T. Marinetti,
'The Futurist Manifesto', 1909, first published in *Le Figaro*, 20 February 1909;
page 129 Tania Bruguera, Manifesto on Artists' Rights, 2012, first presented at
the office of the United Nations High Commission for Human Rights at the Palais
des Nations in Geneva in 2012. Republished in *'Why Are We Artists'? 100 Art World
Manifestos*, selected by Jessica Lack (London: Penguin Modern Classics, 2017),
p. 462; **page 153** Walter Benjamin, 'Exposé: Paris, the Capital of the Nineteenth
Century', 1935, *The Arcades Project*, 1927–1940. Republished in *The Arcades Project*
(Cambridge: Harvard University Press, 1999), translated by Howard Eiland and
Kevin McLaughlin, p. 13.